JOHANNA DIEHL
NIKLAS MAAK

Eurotopians
Fragments of a different future

HIRMER

Contents

An Archaeology of the Future ━━━━━━━━

For the first time in a very long time, architecture once again finds itself with a remit that goes beyond providing people with airports, schools, reasonably pleasant public spaces, and homes based on tried-and-tested templates. Over the coming years and decades, an unknown number of people are expected to migrate to the world's major conurbations – and will want to live there. According to a UNESCO study, around one billion people will swell the ranks of those who live on the already overfilled outskirts of major cities. We have no idea how they will live. For ecological, social and economic reasons, the familiar typologies, i.e. high-rises, terraced houses, vast expanses of single-family dwellings or even slums, are not an option for them. So new typologies need to be found as social ritual and the way people work and live have changed fundamentally in result of the so-called technological revolution. These societies have long ceased to consist solely of single persons or nuclear families, the two main categories that still account for virtually all the homes now being built. ━━━━━━━━

Add to this the fact that automation and robotisation will destroy more jobs than they create (despite all the claims that full employment will still be possible in the future) and that this trend will also have far-reaching consequences for housing and for community life. The question of home life will become inseparably linked with the question of work – and not in the idyllic, backward-looking sense that both activities can be re-combined within a single building, as they might have been in mediaeval towns "in the old days". Right now, the widely celebrated blurring of boundaries between working life and home life means that working life – i.e. being constantly reachable, being constantly on a laptop, answering emails at night – has engulfed home life, so much so that it's now hard to imagine home life beyond working

life. Whenever employers graciously offer their staff the opportunity to "work from home", the emphasis clearly is on the word "work". But what if vast numbers of low-skilled workers lose their jobs: What will they live off? In what sort of premises will their private and their public lives play out? And where will we find the models for a form of architecture whose spaces are able to respond to the fundamental new challenges and also enable other, less efficiency-controlled forms of our living together?

Here, our view of things is automatically drawn back to the 1960s, to a time that was shaped by the pioneering spirit of the "Moon Age" and a flourishing consumer society, and that also managed to develop an awareness of ecological and social problems and work on political and architectural counter-models. Both – the expansive optimism and the ability to critique – are reflected in the architecture of the 1960s. ——————————————

Countless coffee-table books on the architecture of the 1960s and '70s have been published since the turn of the millennium. In these books, the buildings of that particular period were often showcased as birds of paradise set in concrete, as wondrous beasts admired (with a hint of nostalgia) for their brash, loud colours, the way you might admire some bizarre 19th-century antique: "Unbelievable some of the stuff people came up with back then." Brightly coloured 1960s furniture and lamps drifted into middle-class homes as interior décor, along with screen prints, an expression of the awareness that there had been a time when things were wild and progressive. The Sixties revolution became a style concept, with the uprising led by lamps and flokati rugs. The restoration of the Noughties aesthetically digested the symbols of political awakening that had characterised their parents' generation. ——————————————

If you look at 1960s architecture today, it's easy to dismiss it out of hand as the crumbling remains of an unredeemed utopia of

late modernity. Many of those coffee-table books do just that, wallowing in a highly aestheticised "ruin romanticism" which, ultimately, merely reinforces the status quo. If the building utopias of yore are decaying so visibly, if the light from the faded plastic lamps of 1971 is glimmering so matt and milky, it's quite all right to carry on as before. ───────────────────

And yet, that is impossible, for the reasons mentioned earlier. It's also impossible to use the formulas of Haussmann's Paris or Ebenezer Howard's garden city to build for a billion inhabitants in the slums of megacities around the world. But if modernity is to be our antiquity, as documenta 12 posited in 2007, it means we must be able to find within its ruins formulas for the present and the future. ──────────────────────────

This book features the works of seven architects who built very different houses in the 1960s and 1970s. Each of these houses was an attempt to fundamentally rethink the notion of living, beyond the known categories and forms. Two of these architects died while the book was being put together. The others, with one exception, still live in these buildings, as if to prove that life within these often bizarre constructs is possible and, perhaps, even better than in ordinary houses; they have persisted with their utopias and demonstrate how compatible they are with everyday life. Meeting these architects was an opportunity to talk to them about the questions they themselves were asking at the time, and about the problems they had to contend with and were determined to solve. ──────────────────────

It is astonishing how close this generation of architects was to solutions to questions that are today more pressing than ever: Why are there only two building typologies for human habitation: the "apartment", usually designed around a family of four and more or less spacious depending on the household income, and the "detached house" out in suburbia? Why are there no

spaces keen to organise social life and co-habitation more open-ly, in networked residential units, along with the question of spa-tial and social interiors and exteriors? Would it be conceivable to re-think and re-work the seemingly obsolete idea of the kibbutz, but in an urbanised, less rural form? And where, now, is the thinking taking place about a new idea of intimate space and public space? Are there any experiments on living space now being conducted that offer alternatives to the economically de-termined desertification of that very space and form, spaces of collective politicisation? Could an idea of public spaces emerge that is not merely defined as an utterly commerce-driven succes-sion of cafés, cinemas and shops, offices and conventional apart-ments, but rather one that offers free spaces for other forms of encounter and a new definition of the private and the public? All these questions were already being discussed in the mid-1960s: questions about living together beyond the scope of the nuclear family; about living in cramped surroundings; about the sort of spaces people want to meet in, and what social life actually ought to be; about how much privacy people need and what the spaces that provide that privacy should look like; and what can be done to counter any manipulation by the commercial interests of cor-porations and politics. ▬▬▬▬▬▬▬▬▬▬

As different as they may look, all the projects in this book rep-resent a critique of a dogmatic-rationalist modernity and the political systems of their time. Restricting the scope to Europe-an examples does not mean that there were no visionary archi-tects outside Europe at that time – on the contrary. The geo-graphic restriction is due solely to fact that in Europe during the post-war period there was a comparable demographic, social, cultural, and political prerequisite for experimental architecture, one which this book is also to showcase: alternative concepts to a blueprint for society that was reflected in architecture and ur-

ban planning in Europe after 1945. And yet *Eurotopians* can only be a first step in the exploration of the architectural experiments of that period and its creators. ▬▬▬

This book is not a nostalgic look back at the ruins of a decade filled with the optimism of progress; rather, it is an archaeology of the future. It searches among the decaying concrete for traces of experiments that were eventually called off due to the economic crises of the 1970s and the triumph of neoliberal capitalism in the 1980s. ▬▬▬

Yona Friedman, one of the 20th century's most influential architectural thinkers, is a trailblazer for the self-empowerment of residents and a political *arte povera* in architecture that can be both light and spontaneous. He is rightly regarded as one of the architects who, though they themselves built very little, have certainly shaped the discourse like few others. ▬▬▬

Less well known by far are the buildings of Milan architect Cini Boeri, famous first and foremost as a furniture designer. Far away from urban centres, she designed houses like micro-cities in which she examined questions of solitude and togetherness, of individuation and community. ▬▬▬

With her green terraced buildings near Paris, the architect Renée Gailhoustet revolutionised social housing. ▬▬▬

For the film director Michelangelo Antonioni and the actress Monica Vitti, Dante Bini designed a house that was not just a sensation in terms of its construction, but also provided a stage and a form for a modern relationship; today it stands like a life-intensifier on Sardinia's seashore. ▬▬▬

Hans Walter Müller has been living inside an inflatable house in La Ferté-Alais near Paris since 1968. With the aid of his pneumatic structures he demonstrates what *instant urbanism* might look like, one that inflates pop-up restaurants and emergency accommodation wherever it is needed – and also that a building

that provides shelter for 200 people does not have to weigh any more than 32 kg. ─────

Claude Parent believed that the way in which we furnish our houses and our lives is repressive in the extreme – and developed the "theory of the oblique", of a life on the incline in houses filled with gentle ramps on which relations between human beings should become more dynamic. ─────

In the hills above Nice and Cannes, Antti Lovag built a luxurious, 1,600 m² situationist bubble to illustrate how even the average layperson could build their own dwelling – and what life might look like once their alienating work had ended. ──

That, too, is one of the aims of this book: to show that, among the visionaries of 1960s architecture, there were many women such as Bini and Gailhoustet, who have since been systematically sidelined from the history of architecture. ─────

For the most part these architects still live in their innovative 1960s world designs; yet are now mostly well into their nineties. And yet each and every one of them stands for an idea of the future we would be well advised to revisit.

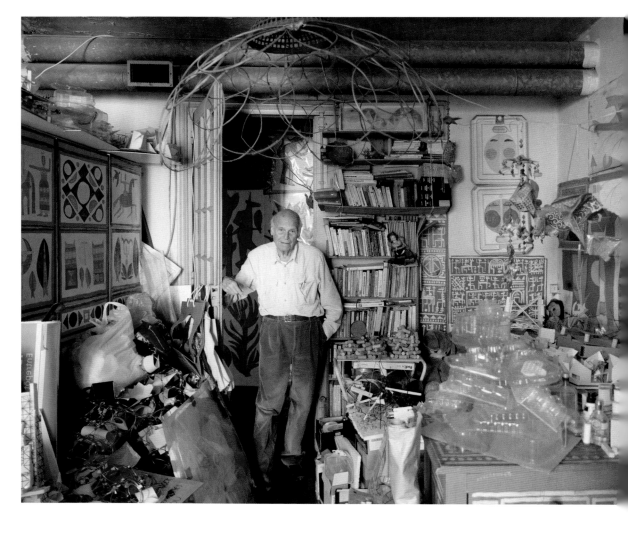

Yona Friedman

It was on a cold January afternoon in 2004 when the idea suddenly came to him, in his small flat crammed full of architectural models, drawings, packaging waste, and fetishes in an old apartment building on Boulevard Garibaldi in Paris.

The apartment itself looked like the enlarged brain of an architect. There were models stacked along shelves; souvenirs hanging from the ceiling like half-baked ideas; thousands of objects lying around that Yona Friedman had brought back from his travels: a brightly coloured elephant, an old stool, Indian fetishes, African masks, a glittering chain, a wooden crocodile, foam packaging, sketches, photographs, pictures, snippets of theories jotted down on sheets of paper affixed to the walls with drawing pins. Even the windows were papered over with drawings that obscured the milky light of a Parisian winter while, down below, the *Métro Aérien* rattled past on its way from Montparnasse to the elegant 16th *arrondissement*. We had spoken about Paris and about Berlin while Balkis, his antediluvian dog, crossed his paws and Florentine, his antediluvian cat, padded across the desk trying to catch the lines that Yona Friedman was sketching on his notepad. We had asked him what he liked about the new Berlin; he replied: "Oh well." Things could have been done differently. How differently? "Send me an aerial photograph and a couple of postcards", Friedman had said, "and I'll sketch you a new Berlin".

A fortnight later he landed in Berlin. The draft designs the architect brought along were urban utopias rendered in Friedman-like style, sketched on photographs: a densely woven floating fabric of buildings, a futuristic landscape of rooftops which, infected by the spinning shapes of the Federal Chancellery, sweeps across the Spreebogen to Potsdamer Platz and floods the urban wastelands of Berlin-Mitte with a typical Friedman maze of flexibly suspended residential units, floating buildings above a bright red supporting structure.

Futuristic hyperbole has always been part of Friedman's method, which is itself designed to advance the thinking about urban development. Friedman gained world acclaim with his idea of a "mobile architecture" and a *ville spatiale*. He became a role model for a generation of architects who, already in the 1960s, began drawing up plans for Asia's high-density cities of the future and made a career for themselves as "Metabolists". For Friedman it was not about building high-rise blocks; his vision was to spread a dense interwoven and overlapping housing carpet across the urban landscape, one that avoided both the melancholy of free-standing box-like residential units and the urban sprawl inflicted on the landscape by endless rows of terraced houses. At the height of a dogmatic modern architecture for the masses that stamped one concrete housing block after the other into city suburbs around the world after 1945, Friedman sought the opposite: open structures that people could nestle into, add to by flexible means, change things around, expand and alter a habitation using lightweight elements, curtains, and furniture.

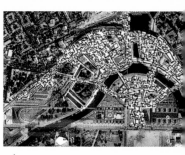

1

In Friedman's vision the ideal city would be more like a rampant jungle, the buildings more like the metamorphosis of a continual processes of alteration and addition, a crystallisation of life itself.

He countered the idea of rigidly predetermined urban planning with that of metamorphosis and improvisation, solid concrete with lightness, and became a pioneer of an ecological approach to architecture. Friedman was never so naive as to believe that the poverty-driven architecture of the *favelas* could serve as a role model for a new way of building, but he did realise that it worked more intelligently than the grid-based cities artificially created on the drawing board. The man who never built a city himself did go on to influence and shape so many architects with this thinking; indeed, it could be argued that his apartment, where he has lived for half a century with all its superimposed strata, is something of a thought model for the mobile improvised city.

Of all the architects who have built almost nothing in their lifetime, Yona Friedman is the most famous and the most influential. While an illustration of his completed projects would barely fill two pages (it could include an apartment building in Haifa in 1952; a school in Angers in

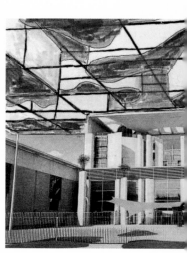

2

1978; the Museum of Simple Technology in Madras, India, in 1982), the stories of his admirers and imitators would take up several volumes.

Friedman was born to middle-class Jewish parents in Budapest in 1923; his father was a lawyer and his mother, a pianist. During the Second World War he joined a resistance group and was arrested by the Gestapo in 1944 for forging papers. But then, says Friedman, he got lucky: the railway lines were blocked and they were unable deport him; and by November the Russians had arrived. In 1946, aged 22, he emigrated to Israel and lived on the Kfar Glikson kibbutz, enrolling at the Technion in Haifa to study architecture.

On 14 May 1948, Yona Friedman, the student of architecture, was sitting with friends listening to the news coming out of Tel Aviv. The Jewish National Council had convened that afternoon; David Ben-Gurion had proclaimed the Declaration of Independence beneath a portrait of Theodor Herzl; 11 minutes later President Harry S. Truman had recognised the new state in the name of the United States of America; a few hours later (by which time the sun had set and Shabbat had begun) Egypt, Saudi Arabia, Jordan, Lebanon, Iraq and Syria had declared war on Israel. Friedman gained his degree in architecture soon thereafter, met his first wife, and got a job with the military, where he was entrusted with settlement security. He was the go-to man for thick walls; the fact that he of all people would go on to become the most prominent forward thinker for a lightweight, open and mobile architecture is one of the paradoxical turnarounds in the history of architecture in the 20th century.

3

As a security expert in the young state of Israel, Friedman designed buildings which, here, looked even more like utopias for a different time. In fact, they were merely grids into which residents could build whatever they needed at that time, which is why he also designed foldable, flexible wall systems, things the authorities had forbidden him from considering when he built his first apartment building in Haifa in 1952. Golda Meir visited his building site and could not understand him. Friedman began to travel and realised that modern architecture was somehow bogged down in a soulless grid-based mode of thinking. It prompted him to present his concept of a "mobile architecture" at the *Congrès international de l'architecture moderne* (CIMA) in Dubrovnik

1 The new Berlin, Yona Friedman for the *FAZ*, 2004

2 The new Berlin/Chancellery City, Yona Friedman for the *FAZ*, 2004

3 Yona Friedman in Israel, *c.* 1950

in 1956. Contrary to what the name might suggest, it was not some insane vision of cities wandering around on stilts of steel, the sort of thing Superstudio would create some time later; rather, it was an architecture designed to adapt to circumstances. A monumental grid into which individual buildings could be flexibly suspended like racks slotting into a rack frame, a structure where the unforeseeable could embed itself.

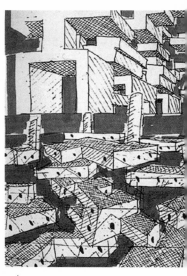

Friedman's thinking was a revolution in architecture. As he saw it, the architect should be someone who builds an open framework that allows the greatest possible freedom to reign: everyone should be able to do what they wanted, and with the shapes and materials of their choice.

Friedman's hastily drawn sketches always featured spectacular locations such as the Champs-Élysées spectacularly submerged under a *ville spatiale*. They have also been just as irritating as Le Corbusier's demolition plans for Paris were three decades earlier. "It'll be too dark beneath these floating cities", complained the critics; "these were sculptures, not architecture", they claimed.

4

Others proved that it was possible – and it's an irony of history that Friedman himself was never able to build any of the things that would have been inconceivable without him. Moshe Safdie's residential city at *Expo 67* in Montreal was a shamelessly direct application of Friedman's concept of the *ville spatiale*, illustrating how well the Hungarian's seemingly abstruse urban fantasies actually worked in practice. Instead of a monotonous high-rise, Safdie stacked countless residential cubes on top of one another. In appearance the end result resembled an abstract Italian mountain village built out of concrete.

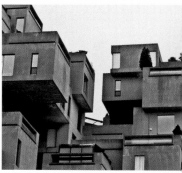

Also, the green high-rise with parks and public amenities stacked like a club sandwich – an idea with which the architects at MVRDV became all the rage at the World Exposition in Hanover in 2000 – was in fact nothing other than Friedman's 1979 idea of a "green architecture". And Bernard Tschumi's Tourcoing theatre, a superimposition of platforms over an old hall was nothing other than a *ville spatiale* on a smaller scale. (Even Tschumi's favourite notion of "superimposition" is to be found in the manifesto Friedman published in 1956, *Architecture Mobile*.)

5

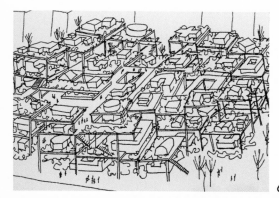

6

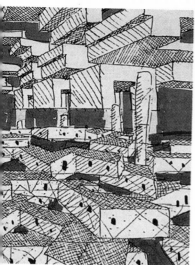

As stated earlier, Friedman, who moved to France in 1957 and has lived in Paris ever since, did not build any of it. He has preferred to venture towards the outer boundaries of the architecturally conceivable, and many ideas were mere futuristic thought experiments, like linking all the continents with inhabitable bridges hundreds of miles long. However, other projects did pre-empt today's theories of urbanism.

Friedman worked not just as an architect: together with his second wife, Denise, he shot a number of animated films (one of which was awarded a Golden Lion in Venice in 1962). He also wrote a book about his dog and conducted experiments on sign theory. And so, for many years, it almost seemed as if he had been forgotten as an architect. But then Friedman surprised everyone with new installations, for instance at the Venice Biennale in 2009, where he used Styrofoam packaging from TV sets and stereo systems to create a frenzied urban model, an *architettura povera*, a vibrant trash city that looks like a forerunner of his vision for a dense Berlin city centre.

Early on, Friedman was interested in how urban structures emerge under the chaotic conditions of South American and Asian slums. Indeed, the current enthusiasm for *favela* culture owes him a great deal as someone who, since the late 1950s, has travelled to the shantytowns of the Third World and, on behalf of UNESCO, has tabled entirely non-utopian proposals for flexible *favela* architecture.

At the turn of the new millennium, Friedman designed a bridge for Shanghai that was actually meant to be a city floating above the water. The client even suggested he move to Shanghai and offered to give him a house as a gift. He declined, as his wife was seriously ill; she died shortly afterwards. His dog Balkis and his cat Florentine, who had lived among the old architectural models from the 1960s, both died, too. At the time, his whole apartment had been crammed full with hundreds of models and, occasionally, whenever Friedman pulled one of them off a shelf, his cat would fizz out angrily from one of these future cities.

The Getty Research Institute later acquired Friedman's archives. They retrieved virtually all the models and plans from his apartment; bizarrely it looked none the emptier for it. It was still a tangled confusion of drafts, wooden African elephants, fertility bracelets, and birdhouses.

4 Yona Friedman, *Ville Spatiale*, 1959

5 Moshe Zafdie, *Habitat 67*, Montreal 1967

6 Yona Friedman, *Sketch for a Ville Spatiale*, 2004

In fact, it still looks like Friedman's brain, and when you follow him as he walks through his rooms, you have the strange feeling of walking around inside his head, inside a thought construct that consists of constantly recombining assemblages of whatever is there in the apartment.

Only now, it would seem, are all his ideas taking shape in his oeuvre, ideas that influenced so many architects. In 2016 the 93-year-old indefatigable Yona Friedman travelled to London to present a model made of lightweight tubular steel structures in Kensington Gardens: an array of stackable open cubes composed of steel rings capable of supporting floors and ceilings, continually expanding to create a *ville spatiale* in which residents have the opportunity to build, rebuild and build over everything the way they want it, flexibly and spontaneously. There it was again, the architecture without architects, a weak-form structure that is not about creating sculptures, but networks and platforms in which life in its entire unplanned form embeds itself – of a kind the architect had been calling for since 1956 with his all-out attack on the dogmatic and technocratic modernity of the post-war era. Rarely has a solution to the problems of a future city looked as conceivable as it does here.

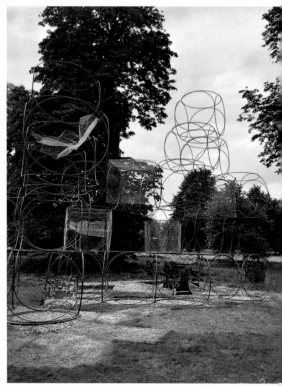

8

7 Yona Friedman, *Serpentine Pavilion Project*, 2016

8 Yona Friedman, *Ville Spatiale*, undated

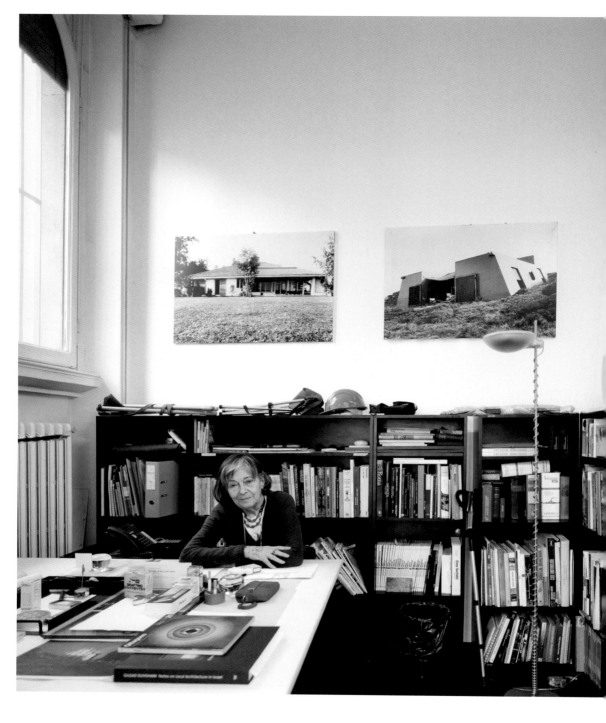

Cini Boeri

It began with Mr Yes. Mr Yes came onto the scene at some point in the 1960s when Stefano Boeri was still a child. No one knew what his real name was. Mr Yes was the boyfriend of Stefano Boeri's aunt and, evidently, he would say "yes" to everything, hence the name. Mr Yes had lots of money and, in 1966, he commissioned Stefano Boeri's mother, the designer and architect Cini Boeri, to build a house for the aunt at a remote cove at Punta Cannone on the island of La Maddalena off northern Sardinia.

Cini Boeri designed a remarkable house, the Casa Rotonda, a circular building embedded into the rock. The living areas are arranged over two floors around a circular inner courtyard sheltered from the prevailing wind; in fact, it opens up towards the sea like a theatre stage from antiquity. In this project, the architect Cini Boeri had already begun to formulate an idea that would later re-emerge in even more detail in her own house, which she built right by the beach, between the rocks, within sight of the Casa Rotonda. A house as a small city whose individual rooms are actually small houses clustered around a central piazza, a stage for the family and their friends, acting out everyday life as festively as a theatre play: here, anyone leaving a room is able to make a grand entrance.

Cini Boeri is one of Italy's best-known 20th-century designers. What is far less well known is that Boeri also worked as an architect. Having studied at the Politecnico in Milan, she worked for the architect Gio Ponti. She made the acquaintance of Marco Zanuso and designed his house for him before opening her own offices in 1963, as one of only a handful of women to have studied both architecture and design.

In the years that followed, she designed the *Lunario* table, its glass top projecting so far beyond the polished chrome base below it that the entire assembly still looks like an optical illusion, even when you're standing in front of it. As early as 1967, long before it was commonplace,

she designed the wheeled *Partner* suitcase, and it remains one of the most beautiful of its kind to this day. She designed the *Botolino* chair, a small stool with castors that came upholstered either in light-brown leather or long-haired fur, in which case it looked like the definitive *botolino* or "little yapper". These items of furniture were not designed to remain static within the home like immutable, firmly anchored sculptures; rather, they were meant to be scuttled about the home to wherever they were needed, like small manic animals. Her best-known sofa design, the *Serpentone* of 1971, is an example of furniture that is able to flow around and trough the chaotic life within the home. It consisted of 37 cm wide polyurethane foam elements that were connected with lamellas. It meant that any number of these lamellas could be linked together to create a four-seater, five-seater, or potentially a seat of unlimited length that could wind its way through the home like a snake (hence its Italian name), forming an elongated classic sofa, but also a circle or an S-shape. Here again, the furniture is be allowed to flow around home life rather than being constrained in a static position.

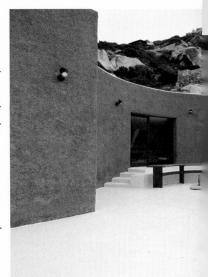

The first time we met Cini Boeri in Milan, she was standing at her apartment window on Piazza Sant'Ambrogio. She was looking across at the rectory opposite, where she was born in 1924 and where she grew up; her mother's husband was the chief municipal officer there. He was not, however, her biological father; her biological father was a wealthy Milan dandy, something she only discovered when she was an adult. Before that, he was simply referred to as an "uncle". In front of a bookcase in her apartment containing the writings of Karl Marx and Claude Lévi-Strauss, there are photos of her as a young woman. She met her husband, a Milan neurologist and resistance fighter, during the war. There is a photograph of her as a very young woman on her honeymoon: wearing sunglasses, she is seated in the passenger seat of a Fiat Topolino estate in which the young couple travelled around war-damaged Europe. There is another photograph, one that was taken by her son Stefano, himself a recognised architect and the recipient of numerous awards for his *Bosco Verticale* in Milan; it features his mother and his two brothers. Twenty years later, Cini Boeri herself is seated at the steering wheel of a Daimler convertible and is now regarded as one of Italy's foremost designers: her

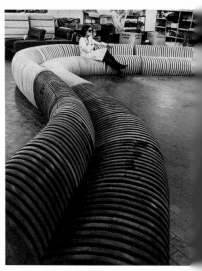

2

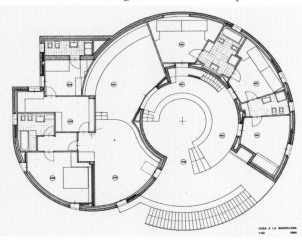

3

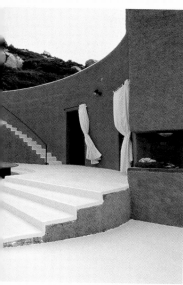

1

story is also the story of emancipation. For her family, in 1967 she designed the house she calls Casa Bunker, because it is painted dark grey and because it is shielded outwardly yet opens up inwardly, as if to protect the entire family. And yet, as Stefano informs us, the time-bomb ticking away was inside the building: his parents split up the year the summerhouse was completed, and his mother travelled with her sons to Paris and took part in the city's May 1968 riots. Like many Milanese, she was a communist, and the house she built in that lonely cove at La Maddalena went from being a retreat for her nuclear family to a gathering place for Milan's intelligentsia, who spent entire summers there, sleeping naked up on the flat roof during Sardinia's hot sticky summer nights, engaging in endless discussions about the revolution and the potential threat of a putsch by the Italian military. Stefano explains that some of them wanted to organise, from Sardinia, resistance to any military dictatorship that might arise. There is a great deal his mother no longer recalls. She is, after all, 93 when we meet and, as we chat, she keeps introducing herself impeccably and most graciously every five minutes, placing her hand on the guest's arm in the middle of conversation to say, "Io sono Cini, e tu?" (My name's Cini, and you are…?). But she does remember precisely what happened in the 1960s and '70s, the discussions in Milan bookstores, and the fact that the small house on La Maddalena became a remote and secluded centre for Milan society's discourse: indeed, society itself was being re-designed by the sea.

Like Miuccia Prada, who is a generation younger, Cini Boeri belonged to a social stratum whose left-wing political consciousness did not end in a doctrinaire, ultramontane rejection of all the blessings bestowed by capitalism; more than anywhere else in the world, it was possible to be left-wing in Milan – and even on the radical left – and still own holiday homes and sports cars and wear expensive clothes.

Cini Boeri still travels to Sardinia, to La Maddalena, to her Casa Bunker, which, when she designed it, was also perhaps some sort of speculation on the future life of her sons, who were still young at the time. Each of them had a room where, one day, they might be able to live with their family. All the rooms converge towards a "sunken living room" that contains the record player and a couple of sofas. The topog-

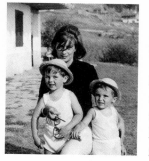

4

1 Cini Boeri, *Casa Rotonda*, Punta Cannone,
 La Maddalena, 1966

2 Cini Boeri, SERPENTONE/Arflex, 1971

3 Cini Boeri, floor plan for the *Casa Rotonda*,
 Punta Cannone, La Maddalena, 1966

4 Cini Boeri with two of her sons

raphy pushes through the rigid design and genuinely transforms the building into a small village, with its individual rooms clinging to the rock like houses to a cliff. From the living room, the house opens out onto a loggia which, in this particular staging, serves as the public space, and then out towards the sea. This way of resolving a single-family house and its rooms into small individual dwellings is something that would be rediscovered as a life model only much later, i.e. most recently with the Moriyama House in Tokyo, where the architect Ryue Nishizawa has built a miniature town comprised of ten separate residential units one to three storeys high, reminiscent of individual rooms in their own right. While the largest is occupied by the owner and client himself, Yasuo Moriyama, the others are rented out. Nishizawa worked on the plans for two years. First, it was to be a house with corridors laid out under the open sky; then they became small gardens, and the rooms were moved apart to become small individual houses. The corridors between these mini-houses are not roofed over; instead, they form a sort of labyrinthine garden, with trees growing between the dwellings. When the building was completed, it was celebrated as a revolution in residential architecture, an innovative type of living environment, a stage setting, a small town with houses the size of individual rooms.

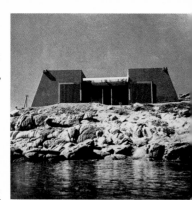

5

What happened in Tokyo had already happened on La Maddalena: a single-family house had become a town on a small scale.

In both instances, all sorts of people lived together in the smallest of spaces, beyond the scope of a family unit. In both cases, a form of de-ideologised communitarianism was turned into architecture, exemplifying a way of life that questions the compulsion towards isolated, compartmentalised private homes in the conventional sense. If the dream of "my home is my castle" is the manifestation in building form of a late-capitalist defensive individualism that has succeeded in annihilating itself, along with its owner-occupiers, then what we have here is a new opportunity for life after the collapse of a Westernised affluent society doggedly founded on a fundamental right to representative detached single-family houses, against all economic and ecological rationale.

Access to the roof of these individual residential units is by a small ladder, so people can have breakfast together in the morning sunshine

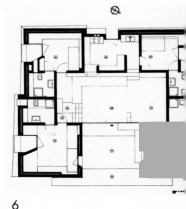

6

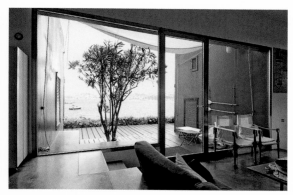

8

and meet with other residents for a chat. And that is precisely what happened four decades earlier, in a small cove on the Mediterranean so far removed from all the centres of activity that the history of architecture, too, has overlooked it.

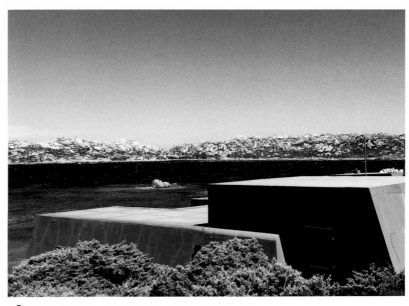

9

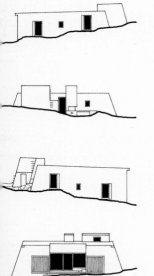

5 *Casa Bunker*, 1967

6 Floor plan of *Casa Bunker*, Abbatoggia, La Maddalena, 1967

7 Sketch of *Casa Bunker*, Abbatoggia, La Maddalena, 1967

8 *Casa Bunker*, Abbatoggia, La Maddalena, 1967

9 *Casa Bunker*, Abbatoggia, La Maddalena, 1967

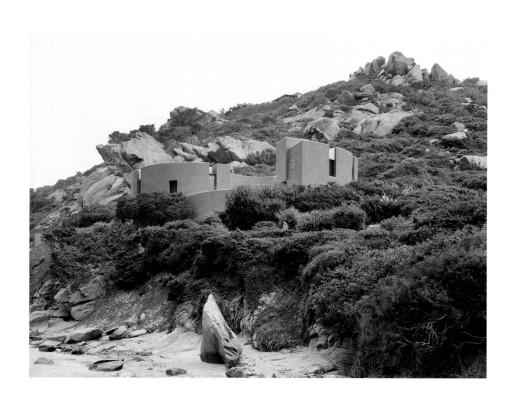

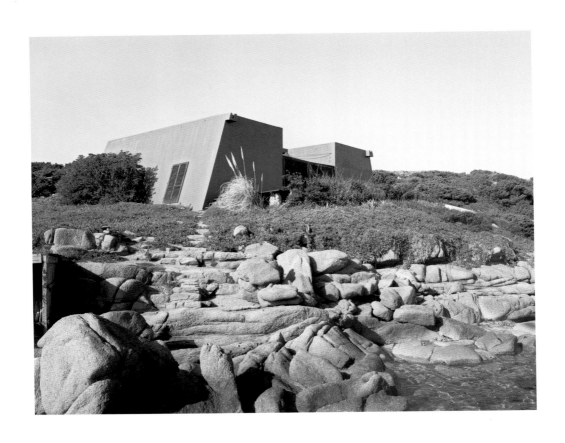

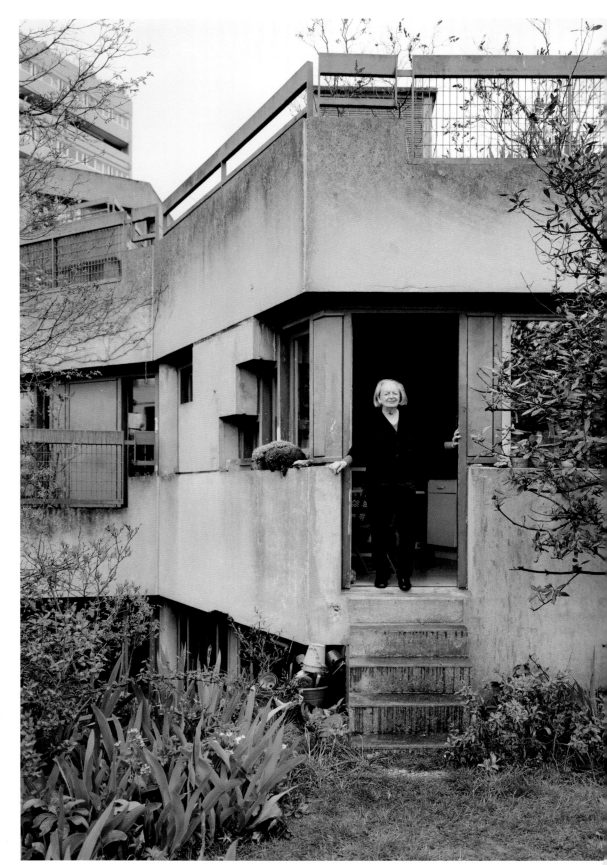

Renée Gailhoustet

The suburb of Ivry-sur-Seine looks pretty much like many other suburbs in the Paris *banlieue*: at its centre a few squat unostentatious townhouses dating from the late 19th century, the ground floors taken up by bars with pinball machines and Chinese fast-food restaurants; adjoining them, as if startled out of a deep slumber, a couple of very old houses from a time when this area was still a village – and behind them, looming ominously like geometric storm clouds, the endless stacks of residential units, the *bidonvilles*, the *HLM*s, France's very own brand of grid-based social housing projects which, if anything, have merely aggravated the social problems that already exist in these suburbs. But there's also something else in Ivry-sur-Seine: a sort of hilly landscape of grassed or planted concrete terraces that extends right across a shopping street visibly inspired by the Paris arcades of the 19th century. The ground floor of these residential pyramids comprises small libraries and kindergartens, with alleyways and walkways branching out from the public spaces. There are no streets; instead, there are small squares and paths of the kind you might find in a mediaeval mountain village. Children play on green terraces linked by stairways. Cars disappear underground into multi-storey car parks. Each apartment is different; each has its own roof terrace, more like a hanging garden where people can chat with their neighbours over the fence, just as they would in a rural setting.

These housing complexes with names like Jeanne-Hachette, Casanova, and Le Liégat were built between 1971 and 1986, and they represent the most resolute contemporary critique ever levelled in France at conventional post-war mass housing schemes. Ivry-sur-Seine was certainly revolutionary. Unlike the rent-controlled *HLM* towers next door, where neighbours crammed into residential hutches can observe one another only from a distance across buffer zones of greenery, here, for the price of a social housing apartment, each worker has his or her own 50 m² garden on their doorstep, connected by stairways to the other gardens.

Everything the modern city had done away with – the juxtaposition of places to work and places to live, spaces where children could play without risk, communal areas that create a sense of neighbourhood community, small shops – was there once again, but this time in a stacked form.

One of the architects of this "counter-city", Jean Renaudie, achieved world acclaim with his green residential pyramids; he is widely regarded as a key visionary in post-1968 urban planning. The architect Renée Gailhoustet, the woman who commissioned him and designed the other complex, does not even figure on any of the (already very short) lists of French women architects of the 20th century. And yet she ranks among the most influential exponents of a critical modernity. The fact that the specialist literature only ever mentions Renaudie is also due to a history of architecture in which, prior to the emergence of Zaha Hadid, women architects were nearly always listed either as spouses (Alison Smithson) or as contributors (Charlotte Perriand) of famous (male) architects. So in those instances where she is mentioned at all, Gailhoustet is listed either as Renaudie's wife or as his collaborator. Yet she was neither.

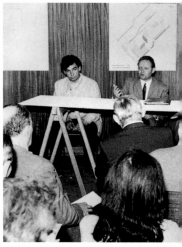

1

Ironically, it was women first and foremost who made Ivry-sur-Seine one one of the most interesting locations for French modernism. The suburb was part of Paris's so-called "red belt". In 1929 the communists, who were in power in Ivry, had fielded a woman candidate, Marie Lefèvre, in protest at the fact that, in France, women were not allowed to take part in political life; the election was promptly annulled by the *préfecture*. After the Second World War, women architects fought hard for gender equality, particularly in Paris; in 1963 the female architect Solange d'Herbez de la Tour organised the first international congress of women architects in Paris. In Ivry-sur-Seine it was the head of the social housing department, Raymonde Laluque, who early on deplored the bleakness of the grey, post-war social housing schemes and called for a new, genuinely social architecture that provided spaces for social encounters – and who also secured the funding to achieve that aim.

And it was against a political backdrop that embraced the experimental that she appointed the young architect Renée Gailhoustet to sit on the Ivry-sur-Seine development committee.

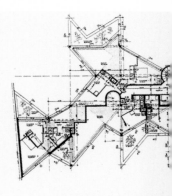

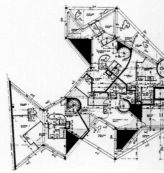

2

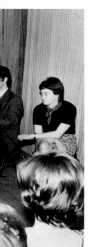

Renée Gailhoustet was not originally from Paris. She was born in Oran, Algeria, in 1929, under French colonial rule. Her father worked for the *L'Écho d'Oran* newspaper. After the war she moved to Paris to study philosophy and literature. She joined the communists and became involved in the street battles between the Left and the Poujadists, of whom the founder of France's far-right-wing Front National, Jean-Marie Le Pen, was also a member. As Gailhoustet now recalls, she had her nose broken in one particular brawl with these *tueurs*. It was the politicisation of those years in particular and the desire to – literally – build a new society that prompted Gailhoustet to study architecture in 1952. Alongside her studies she worked in the offices of Marcel Lods, André Hermant, and Henri Trezzini, who were among the few offices to employ women as designers. It was at Lods that she met the young architect Jean Renaudie, who, like her, was a communist. She began an affair with him that would last until 1968 and had two children with him. It may well be due mainly to the prudishness of architecture historians at that time that, for that reason only, she is listed as Renaudie's wife or (more shamefully) as his partner. Apparently, it was beyond the imagination of – exclusively male – architecture journalists of the day that an independent woman who ran her own architects' office could have a wild love affair with another architect and have two children with him, yet remain entirely autonomous and continue with her own design work.

Even today, the official website of the FRAC Centre states that her buildings reflect just how heavily influenced she was by Renaudie. And yet she was the one who designed something entirely idiosyncratic, well outside Renaudie's ambit. Gailhoustet had studied under Georges Candilis and Shadrach Woods, the architects of Team 10, who were among the fiercest critics of any separation of the functions of living and working in modern-day cities. In 1964 she opened her own offices and began designing residential complexes for many of the communist-governed *banlieues* in Paris. It was as an associate of Roland Dubrulle that she came to Ivry-sur-Seine for the first time in 1962. In 1969 she became chief architect and lead urban designer at Ivry, commissioning her former lover Jean Renaudie, among others.

1 Renée Gailhoustet (right) and Jean Renaudie (left) at a public information meeting on the developement of Ivry-Sur-Seine
2 Renée Gailhoustet, floor plan for Le Liégat, undated

He had worked for Auguste Perret and Marcel Lods and, together with friends employed by Le Corbusier and Jean Prouvé, had founded the Atelier de Montrouge, which was named after the site of Montrouge, but was also metaphorically a "red hill" in the architecture of its day. The Atelier built kindergartens and designed stadiums, all its draft designs being a critique of the non-sensory, coldly rationalistic mass accommodation generated by post-war modernity and a capitalism that organised everything solely according to efficiency criteria. After May 1968 Renaudie fell out with his friends over political issues and founded his own practice. He and Gailhoustet worked on models influenced by the terraced buildings that Moshe Safdie had built for the World Exposition in Montreal in 1967. Ultimately, Renaudie built terraced apartments over the top of a shopping street at the Centre Jeanne-Hachette, with the terraces in front of the housing units actually part of the public space. They are all connected by stairways, and residents climbing up and down past the other apartments along pathways and high plateaus, as one might on a mountainside. Renaudie accepted that people's privacy inside their glazed apartments might be somewhat compromised as a result; as the aim ultimately was to achieve a new form of collectiveness.

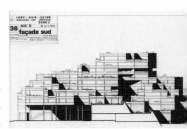

3

It has been claimed time and again that Renée Gailhoustet adopted the stepped terrace principle from Renaudie for her housing complex at Le Liégat. But when you visit the architect in her apartment (she still lives on site), you quickly realise that her building complex is also a critique, a counter-model to Renaudie's radically more public façade area. Renaudie built his public space over the top of his residential pyramid, like a green envelope. By contrast, Gailhoustet developed a system where rectangular oblongs are built onto a basic hexagonal shape. The shape is then offset and stacked in such a way as to create up to ten storeys with projecting gardens and maisonette flats. Here public life does not take place in front of the terrace door, as it did with Renaudie, but on the ground floor, where Gailhoustet built an elaborate tangle of alleyways, small squares, and loggias. Incorporated therein are workshops and shops and communal areas that have the grand, opulent ceiling height of old Paris shops and lots of space for kindergartens and birthday celebrations.

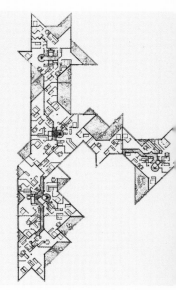

3 Renée Gailhoustet, view of Le Liégat, undated

4

4 Renée Gailhoustet, floor plan for Le Liégat, undated

5 Renée Gailhoustet, Le Liégat under construction, undated

A stage on a small, half-covered square provides a space for performances, small concerts or political debates. Life together as a community is played out in these spaces. The apartments are private. With Gailhoustet, the gardens – up to 50 m² in size and now overgrown like a jungle – are more like additions to the apartment's secluded space, extensions of the intimate sphere into an outside space that is shielded; small garden gates open onto ladders and steps that, with the neighbours' agreement, allow one to enter their gardens and inner courtyards. "With my design", explains Gailhoustet, "the terraces are more intimate; sometimes they even become part of the apartment, like a patio. There are no façades opposite. What I tried to do is create a flowing space by twisting very simple shapes that connect to a hexagon. The apartments are not boxes that are simply juxtaposed. For me, it was not about achieving a purely right-angled space; everyone here has a garden at the back, as they would do out in the country, one that communicates with the other gardens. It's also an architecture designed with children in mind: no cars, no streets, just paths and squares."

Le Liégat consists of 140 rent-controlled council-owned flats. The rent is EUR 800 for an apartment comprising two storeys, five rooms, and a paradise garden with views of the city. There is plenty of space here for a large family to live, but also for a flat-share or a group of the elderly.

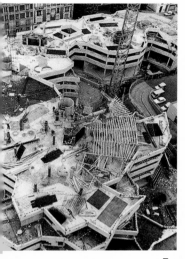

5

Gailhoustet's housing complexes are an example of a government-funded house-building policy that creates space for other lifestyles beyond that of the classic nuclear family. It does not delegate the task to private developers, who usually build homogeneous middle-class dwellings – while speculating on increases in house prices as a result of their property ownership. Gailhoustet's Lenin Tower (1963–1968) (given the names, there is no mistaking which party had been in power since the 1920s) demonstrated how shops and studios could be incorporated into a housing complex; her Spinoza Ensemble (1966–1973) had a children's library, a kindergarten, and a venue for young workers to meet and talk. Gailhoustet also gave some thought to the role of cultural output within the urban space. In her "housing mounds" in Aubervilliers, i.e. the Maladrerie district (1975–1986), she incorporated 40 artists' studios. It meant there was always someone there working at the

housing complex during the day and that children could come and go as they pleased. In the meantime, the complex could certainly do with a facelift: while some of it looks quite run down, there is also something quite mediaeval about the brutalism of the architecture, the concrete now looking like an ancient overgrown stone.

Of all the housing experiments to emerge in the 1960s and then subsequently be abandoned, the high-density, urban terraced construction developed by the likes of Safdie, Gailhoustet, and Renaudie is the most interesting. Firstly, because it still serves as a model for a new collective urban architecture that provides space for other ways of life and alternative lifestyles and social rituals. Secondly, because it shows, especially in the case of Le Liégat, how French politics between 1962 and 1973 enabled radical reinventions of urban building and living.

Two bursts of modernisation have propelled France forward as a nation since the founding of the Fifth Republic in 1958: the first was technological and infrastructural, under the presidents de Gaulle and Pompidou; the second was socio-cultural, after 1981, when the socialist François Mitterrand became president. When France lost her colonies, there was an enormous influx of both colonial Frenchmen and women as well as Algerians and Moroccans to mainland France. Indeed, France found itself in a strange state vascillating between depression (due to the loss of global significance) and euphoria (due to growing domestic demand). It was during these decades that the TGV was invented, that Robert Opron and Paco Rabanne designed France's signature aesthetic for the Moon Age, with turbo Citroëns and sequined dresses. Emerging alongside these hastening dreams of Gaullist modernism were revolutionary new forms of mass housing in architecture as an alternative concept to the rationalist tower blocks of the *bidonvilles*. They included the terraced apartment buildings of Ivry, which were aimed at a radical democratisation of what had previously been elitist pleasures. The roof terrace buildings of Ivry are also a late legacy of the utopian Charles Fourier, who gained fame in the early 19th century with his proposal to house the working classes not in dingy little houses, as was the case in Germany and Britain, but in a replica of the Palace of Versailles, where 1,600 workers could live as wildly and as carefree as only the aristocracy

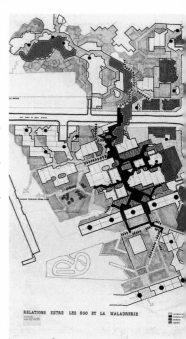

6

had done previously. There would be indolence and orgies for all, plus childcare, community restaurants and washhouses (so women could also go out to work rather than attend to the household) – and a large hall with a jungle in which it was always summer.

France's modernity: it was, on the one hand, the (somewhat Gaullist) enthusiasm for high-speed trains, fast Citroëns, and an early brilliant form of the Internet, the so-called *Minitel*, the development of which had been commissioned by President Valéry Giscard d'Estaing in the 1970s; it came online in 1982 and provided millions of French people with access to electronic information services. On the other hand, it was the democratisation of education and housing, experimental housing, the promotion of popular culture by the socialists following their election victory in 1981.

After Mitterrand at the latest, these expansive dreams of French modernity gave way to an obsession with security and comfort. Though run down and mossy, the large-scale housing experiment of Le Liégat can now be seen as a shining beacon for new ways of thinking about society and communal living.

6 Renée Gailhoustet, site plan for Le Liégat, undated

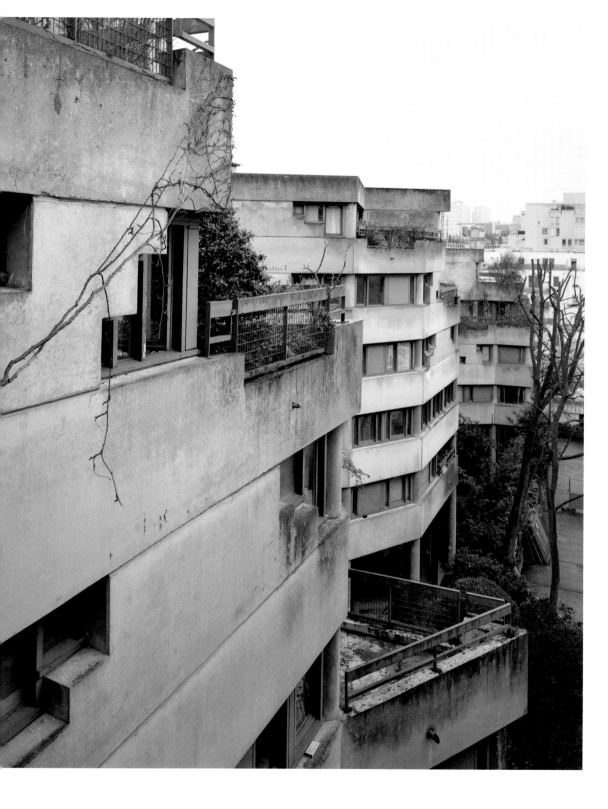

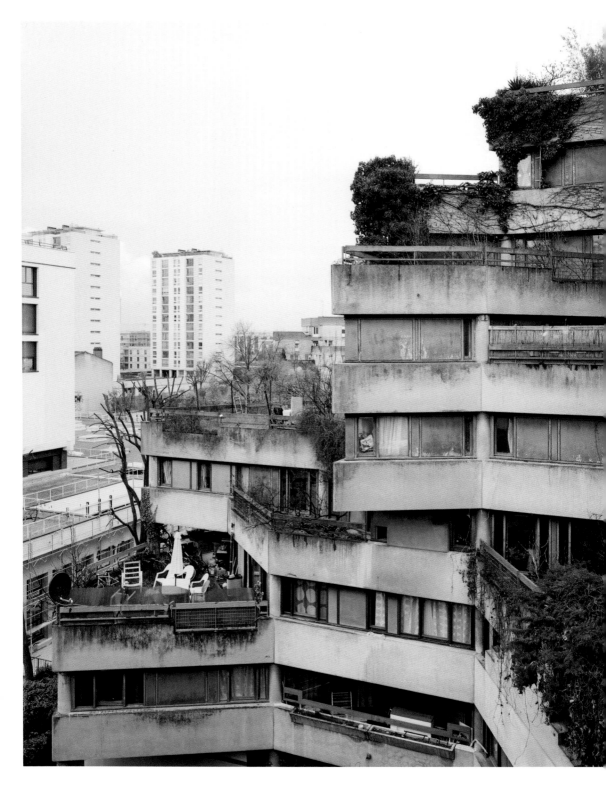

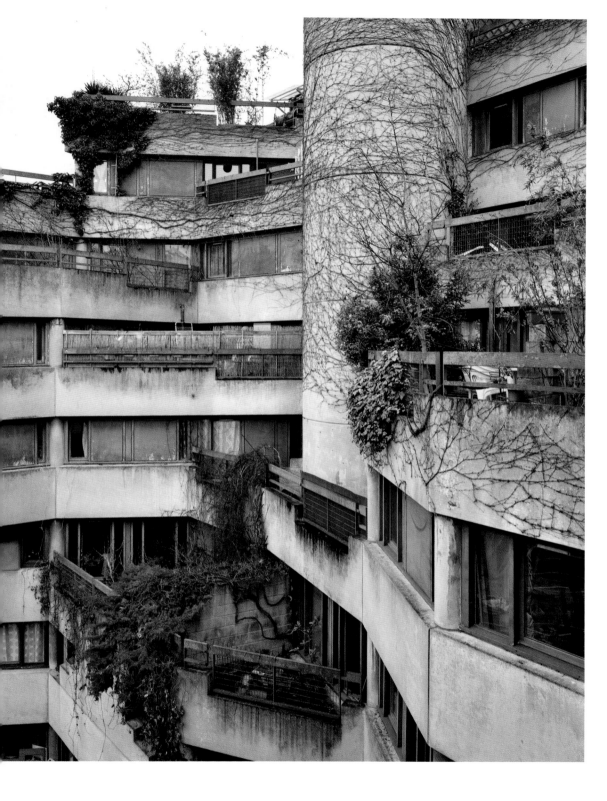

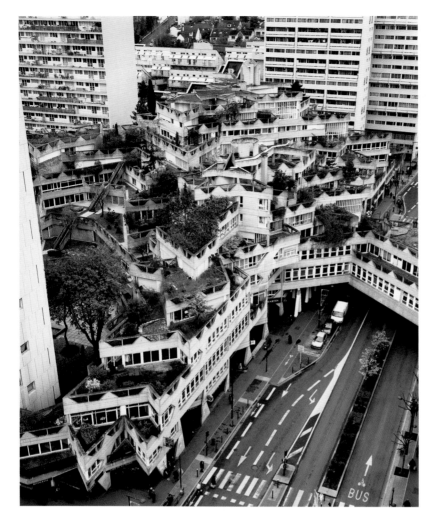
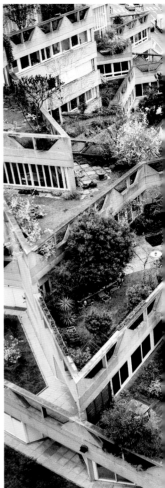

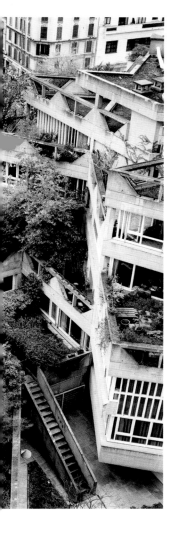
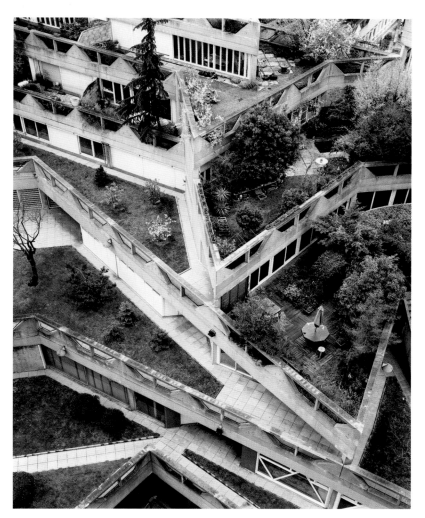

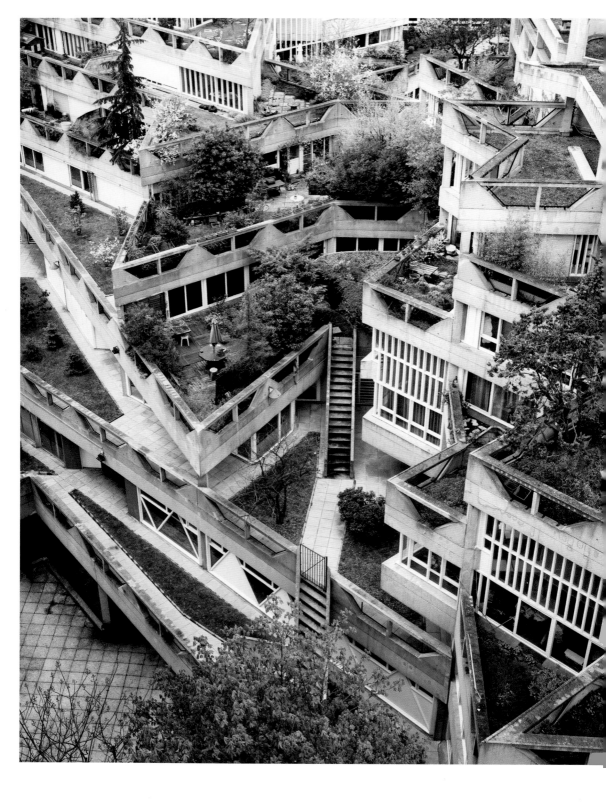

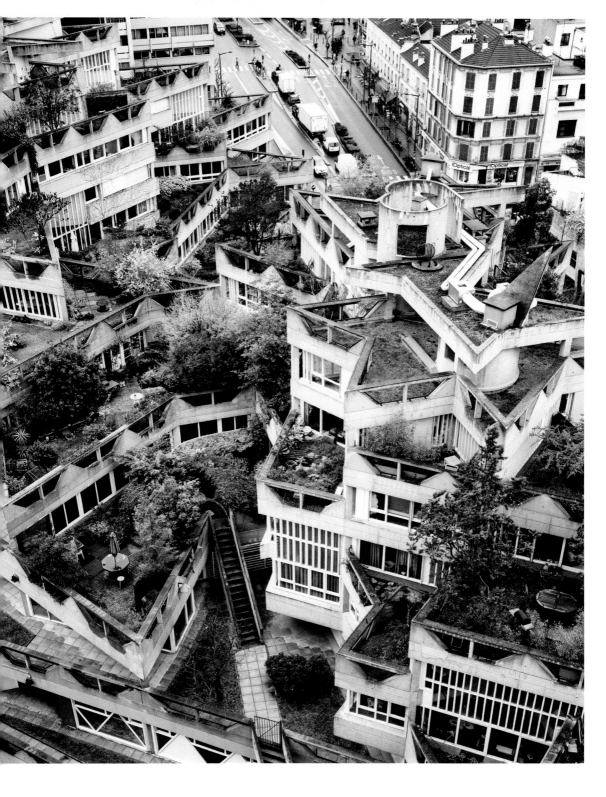

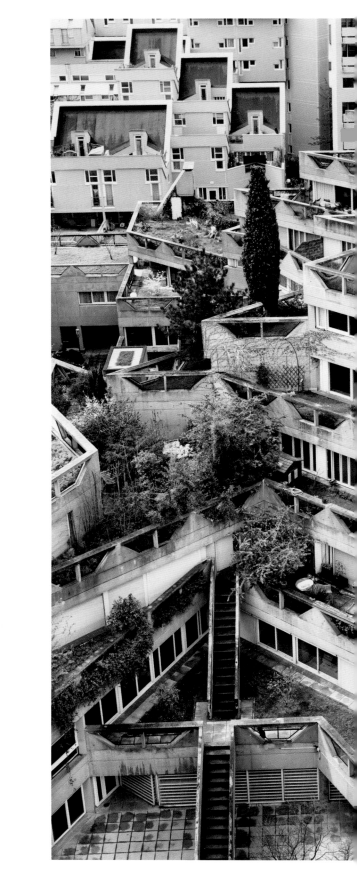

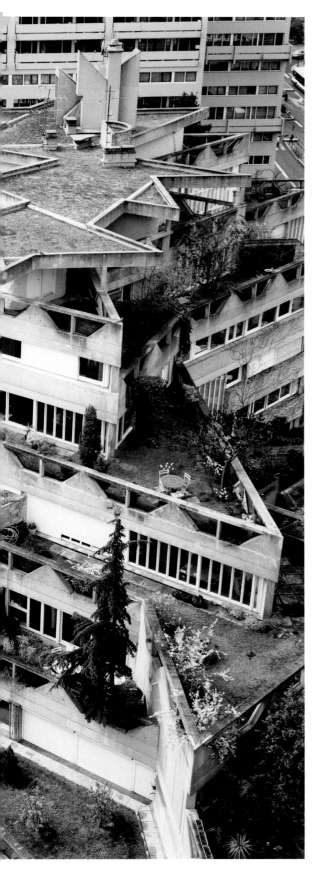

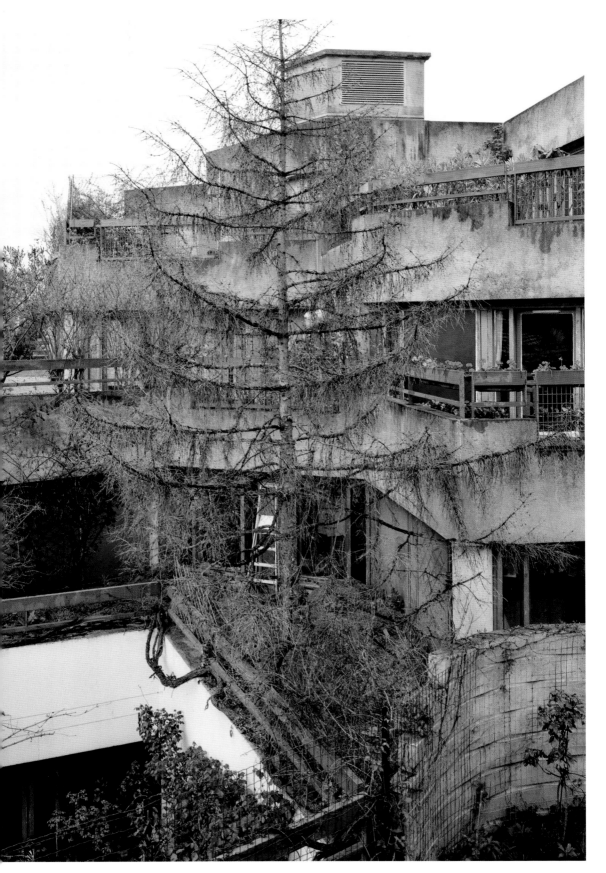

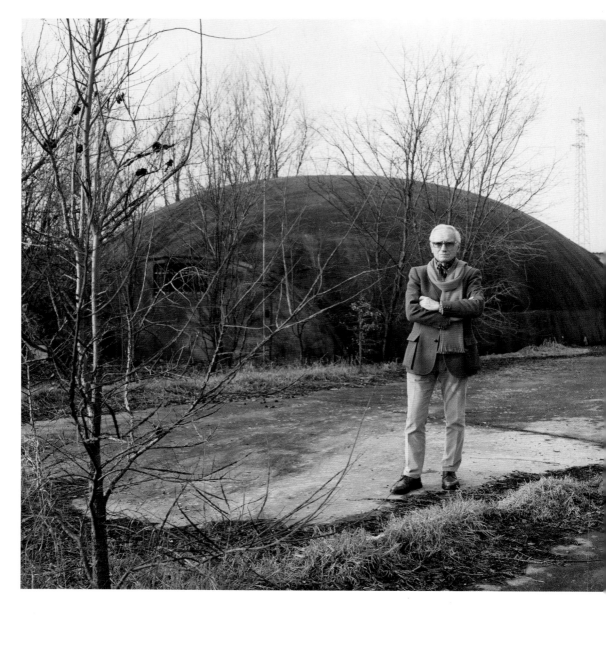

Dante Bini

The story of this house by the sea begins in the mountains, in Cortina d'Ampezzo, where the young architect and inventor Dante Bini won a skiing competition in the late 1960s. The winner's trophy was presented to him by the actress Monica Vitti. Bini was born in Castelfranco Emilia in 1932 and, by that stage, had already designed an award-winning collapsible box for carrying wine bottles and registered a patent for his "Binishell", i.e. a construction technique that involves covering a house-sized rubber balloon with a steel framework, spraying it with concrete, and then inflating it so the structure as a whole slowly rises. The balloon is extracted a few days later once the concrete has cured; doors and windows are then cut into the dome that has been created.

Monica Vitti's partner at the time, the film director Michelangelo Antonioni, had recently bought a plot of land on Sardinia and was looking for an architect. "They told me they wanted a space, not a house; they wanted to live in a space, not between walls", Bini explained. The film director met Bini at the building site shortly afterwards.

"Antonioni told me he hated straight walls and smooth floors, and wanted to live among the rock. He wanted his house to be redolent of its natural surroundings. He said to me, 'Have you ever tried to smell a rock?' I said, 'Pardon?' He asked a worker to split open one of the red granite boulders. He held the chunk of granite up to my nose and, what can I say, the odour was incredible. They loved the fragrance of wild rosemary. So I built a garden that extended right into the house, so that fragrance would fill every room. And they also wanted to hear the sound of the waves."

Rather than a house, Vitti and Antonioni wanted to commission a sound, fragrance, and sense enhancer. Bini designed a porous concrete shell that sank into the tangle of gorse, rockrose, olive trees and pines, a shell where everything was even more intense in its scent, sound, and shimmer: a *machine à habiter* that intensified the natural setting surrounding the house, but also the relationship around which it was erected.

The concrete shell looked like a hybrid between a sunken revolutionary cenotaph designed by Boullée and a laboratory used for experiments involving a rare, complex and highly volatile gas or some bizarre magnetic forces – and, in a way, that's precisely what it was.

Most summer tourists travelling south along the narrow coastal road from Santa Teresa di Gallura have no idea that this dome at the northern end of Costa Paradiso, a dilapidated holiday village erected in a bay on Sardinia's west coast in the 1970s, had been built for Vitti and Antonioni at the beginning of the decade – and that it would set in concrete one of the 20th century's great love stories.

1

Monica Vitti was born Maria Luisa Ceciarelli in Rome in 1931. By the time she and Antonioni (19 years her senior) came to the northwestern coast of Sardinia, they had already shot four films together: *L'Avventura* and *La Notte*, *L'Eclisse* and *Deserto Rosso*. And for years they had been caught up in a turbulent affair that was reflected in the premises in which it was played out. Antonioni's biographer Charlotte Chandler writes that, in Rome, they lived in two separate apartments, one above the other, "that were connected via a trapdoor and a spiral staircase so they could meet without being seen. When the affair ended, they had the trapdoor sealed into the floor. Enrica, Antonioni's second wife, whom he married after his affair with Vitti, once lifted up the carpet to show me the trapdoor"; a door into the past that could no longer be re-opened.

Antonioni rarely used the *cupola* with Enrica, and it fell into disrepair. It then changed hands several times until it was bought up by a Neapolitan family. From the outside, the structure appears almost forbiddingly simple, but as you enter it, you find yourself inside an astonishing maze of interior and exterior spaces. Like the Pantheon in Rome, the dome is open at the top. Twisting staircases wind their way through the inner courtyard below, leading out onto terraces and platforms: even the innermost part of the building is therefore also outside. Conceptual ideas for two or three different houses were built into the shell, due no doubt to the fact that the building itself was built simultaneously by both an architect and a film director, their ideas and notions of space continually clashing, overlapping and entangling during the construc-

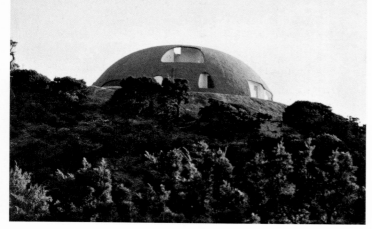

2

tion process. A cinematic notion of narrative here collides with an architectural concept of space. Bini built a device for enhancing nature itself, a mechanism for filtering perceptions: a house prised open so the sound of the rain and the wind could be heard all the more loudly; it was a mechanism that intensified the experience of life itself. Antonioni, for his part, had also turned it into a structured film, a film set for him to play out his life with Monica.

In Antonioni's films, colours and objects are often depicted with almost surreal precision – as if a milky veil has suddenly been whisked aside. Likewise, in Vitti and Antonioni's house, the plants, the furniture, the light, the scents and the smells are showcased like exhibits: the odour of the rocks, the chamomile embedded into the terrazzo flooring, the sound of the waves that echoes more densely, more loudly, more closely, more intensely inside the open labyrinth of the dome, structured like an auditory canal.

At the very heart of the building is the free-floating staircase without banisters, built of rough-hewn rocks rammed into the curved inner wall, a flight of steps down which you balance your way, much as you do down to the bay below – except that this staircase is, perhaps, slightly more dangerous, and deliberately so. It's a monument to danger and beauty, which, for Antonioni, were both correlated – and both demanded concentration, physical tension, and alertness.

Vitti would balance her way down this staircase, one that Antonioni insisted be built even though Bini had provided for two other staircases. Antonioni would sit at the foot of the steps and watch as a scene he so obviously loved continually unfolded: i.e. Monica Vitti, barefoot, stepping down these stones. Like a scene from a film that the house would project for him time and time again.

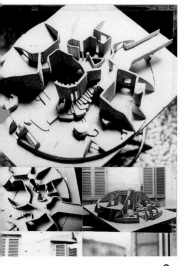

3

Clearly, Antonioni had used the house to build a stage around his obsession with Monica Vitti as she balanced her way up and down the steps, and her bare legs, a recurring motif in many of the films they shot together. The staircase is a scene from a film given architectural form, a moment captured in stone that Antonioni could rewind and play back over and over, a stage for his private obsessions – which is also why the meandering floor plan of *La Cupola* remains baffling to

1 Andrei Tarkovsky, Michelangelo Antonioni and Tonino Guerra in front of *La Cupola*, c. 1982

2 *La Cupola*, Costa Paradiso, Sardinia, c. 1972

3 Model of *La Cupola*, c. 1972

anyone unaware of what these staircases and walkways were meant to retrace or sketch out.

No one really knows what Vitti and Antonioni were seeking at the time, and why they built themselves a summer house in precisely this spot. But we do know that Antonioni was fascinated by the writer Curzio Malaparte, who in the late 1930s commissioned a house on the cliff-top at Punta Masullo on Capri that was as archaic as it was modern. Jean-Luc Godard would later use it as a shooting location for his film *Le Mépris* (*Contempt*), starring Brigitte Bardot.

Malaparte himself died of lung cancer in Rome in 1957, and there are scenes in Antonioni's *La Notte* that directly reference his death. And when you see the stone staircase that winds its way up to the first floor of the dome, where it's as if a UFO had taken a bizarre rock sample in this very spot; when you walk down through the stagnant heat of the cork-oak coppice to the bizarre slabs of rock at the sheer cliff edge where Monica Vitti would lie sunbathing on summer days in the early 1970s, then the entire house seemed like a challenge to this grand programmatic structure. The way in which the Casa Malaparte intensifies the physical experience is almost violent. And when, in a storm, the waves pound the rocks beneath the Casa, the whole house shudders. The *Grande Cupola* is the exact opposite: it's an observatory for things so tiny and indiscernible they are almost beyond perception.

Bini soon disappeared from Sardinia, but not before he had left behind seven other Binishells on Isola di Cappuccini off the Sardinian coast. Since then he has erected 1,600 buildings, including many schools and shopping malls in Australia and America, where in 1989 he devised the Pak-Home, a low-cost earthquake-resistant construction system. He also designed an ecologically sustainable city for a million people in which the city's inhabitants are transported around the metropolitan area on solar-powered walkways rather than in cars or buses.

Vitti and Antonioni lived on the Costa Paradiso for several years. Their concrete house was quickly built, but in fact it was already both a promise and a ruin the moment it was completed. The breathing, vibrant inner part – the balloon – was removed, and then the envelope, the carapace, was pecked open and perforated, the way a seagull pecks open a

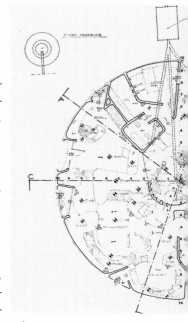

4

5

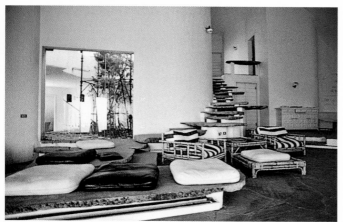

6

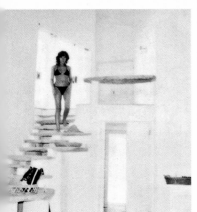

7

crab's discarded shell. *La Cupola* is a paradoxical structure, an extremely simple, coherent form that nonetheless throws up enormous spatial complications: with staircases like the ear's auditory canal, surreal interconnecting rooms, and intersecting spatial segments. It is a marvel of acceleration, but also a place of extreme sluggishness where you meander along a maze of corridors and staircases and bridges, the smells and fragrances and traces of a lifetime trapped as in a filter.

In the early 1970s, as he was parking his car on Piazza del Popolo in Rome, Antonioni made the acquaintance of an art student by the name of Enrica, who had just moved into a commune. Vitti met the film director Roberto Russo, whom she later married. Antonioni died in 2007. Monica Vitti, now seriously ill, still lives in Rome, far from the public gaze.

Roland Barthes once gave a speech in Antonioni's honour, in 1980, in which he stated, "your concern for the times you live in is not that of a historian, a politician or a moralist, but rather that of a utopian whose perception is seeking to pinpoint the new world, because he is eager for this world and already wants to be part of it. The vigilance of the artist, which is yours, is a lover's vigilance, the vigilance of desire", wrote Barthes – and there is much to be said for interpreting this house as one such architecture of desire, of expectation. In his speech, Barthes talked about "that strange phenomenon, vibration"; and you feel it when the wind blows through the oculus into the innermost part of *La Cupola*. It then looks like something that is both very ancient, a wreck, and a vision of the future in which all orders of interior and exterior, nature and house dissolve, where figures from the past and from the future appear simultaneously in one place, almost as in an Antonioni film.

4 Ground plan of *La Cupola*, c. 1972

5 Dante Bini and Michelangelo Antonioni in Sardinia, 1970s

6 *La Cupola*, living room with flight of steps and patio, c. 1972

7 Enrica Fico walking down the flight of steps in *La Cupola*, 1979

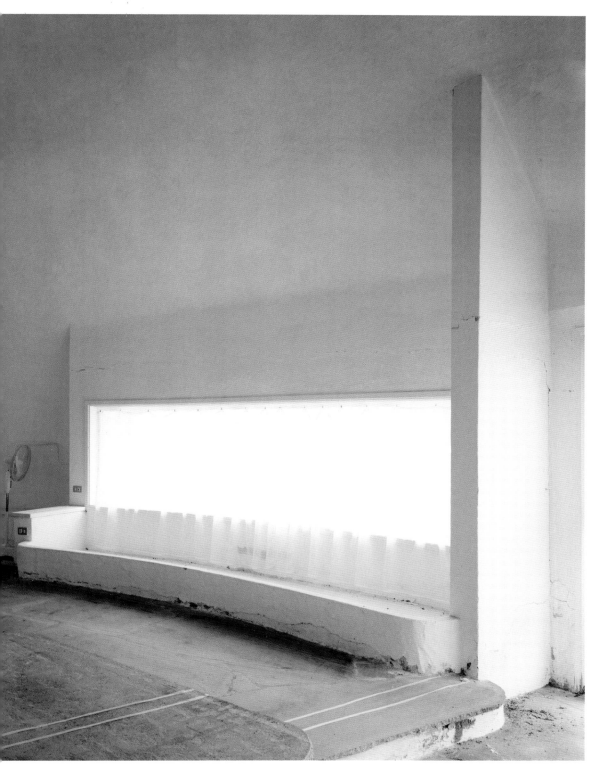

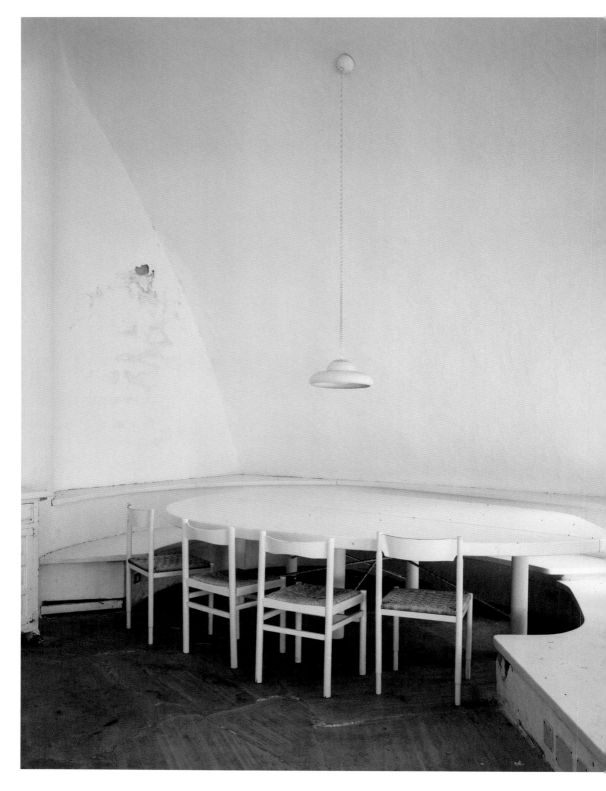

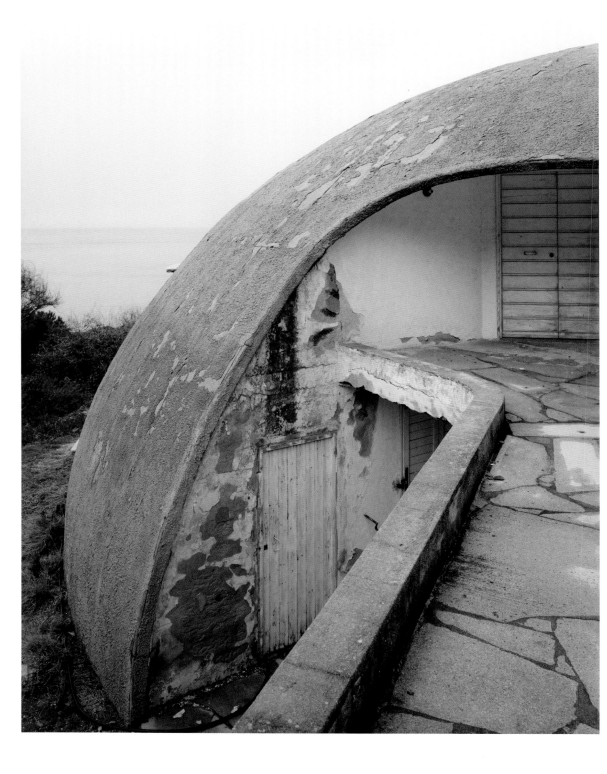

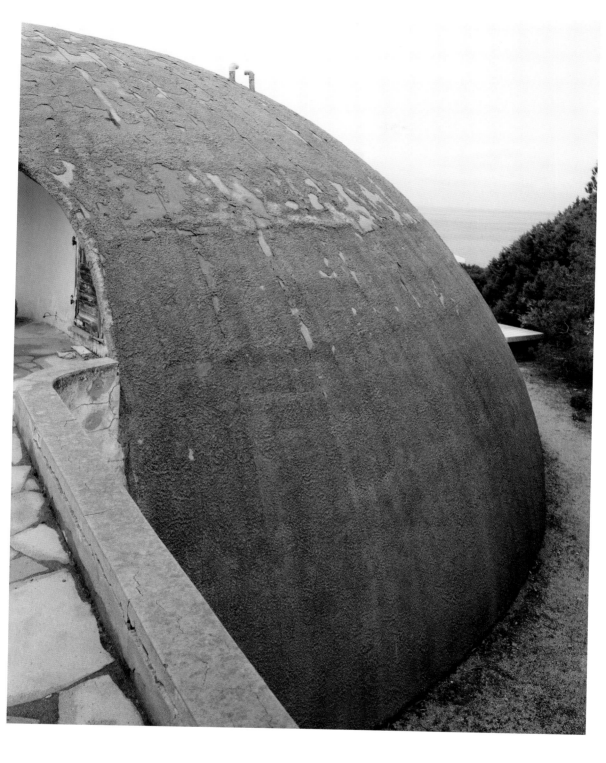

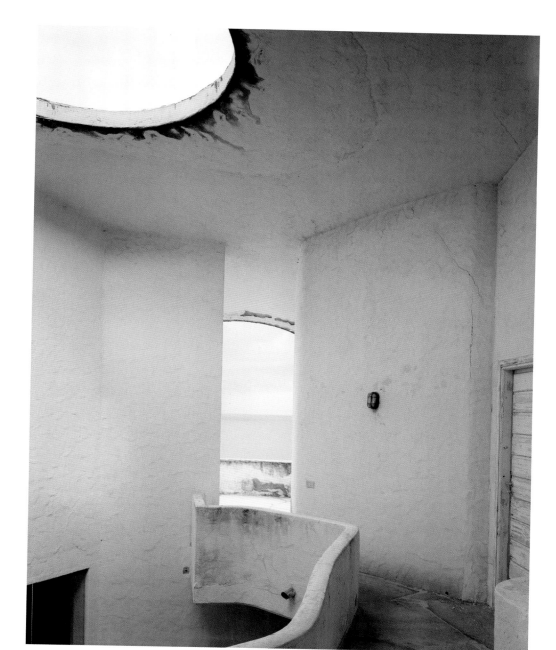

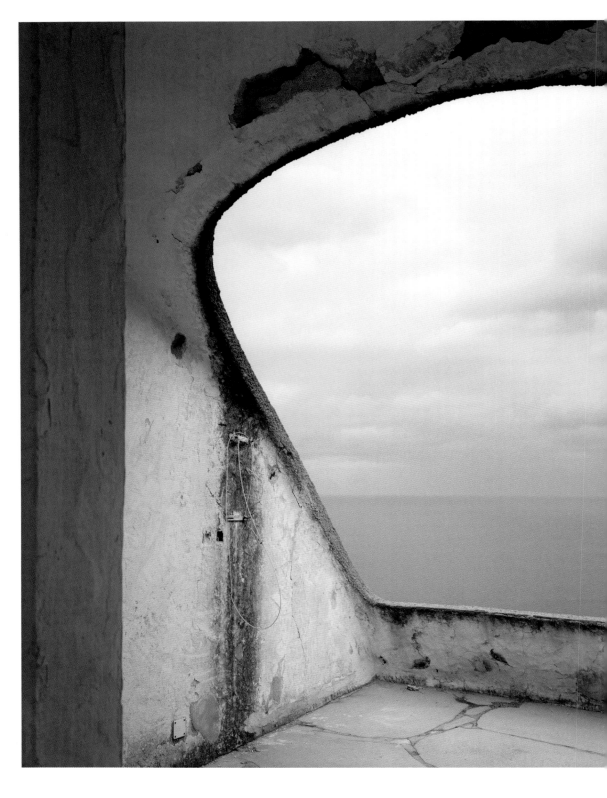

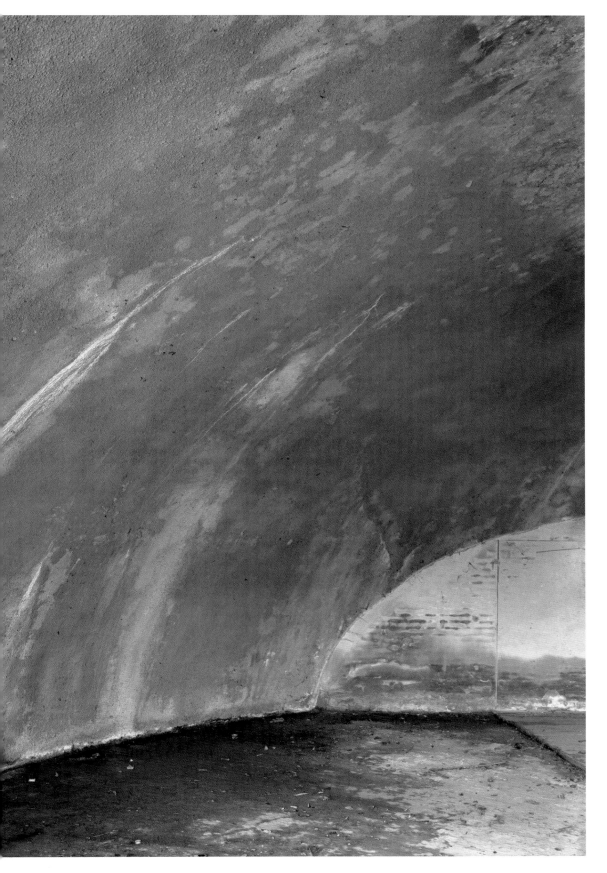

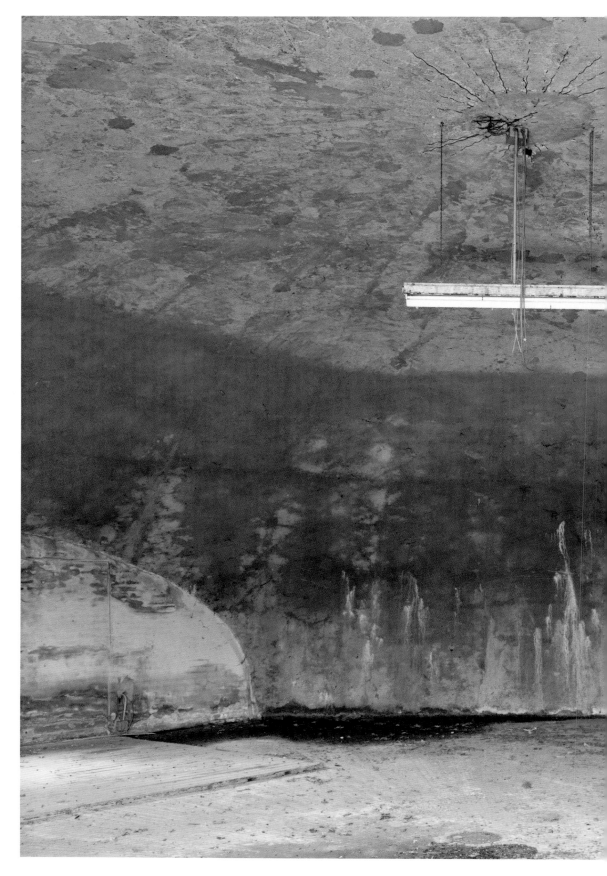

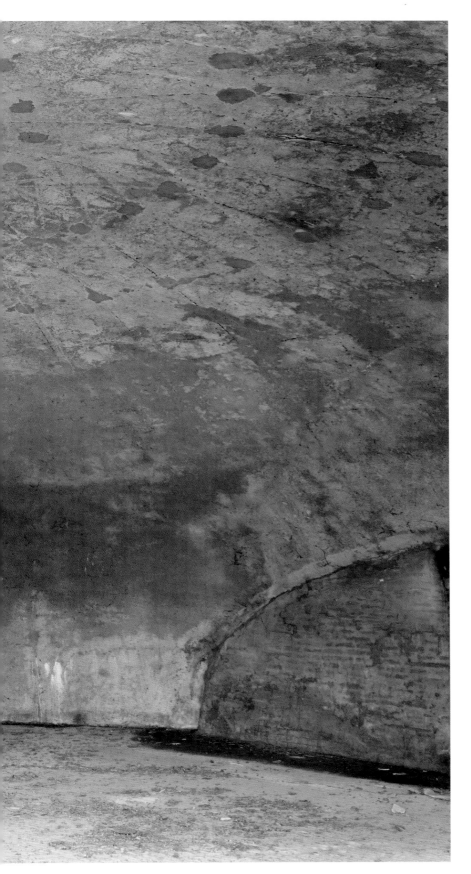

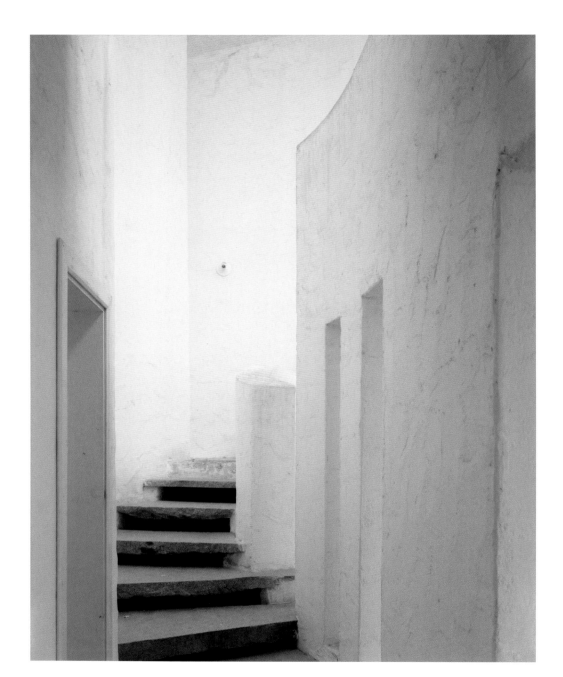

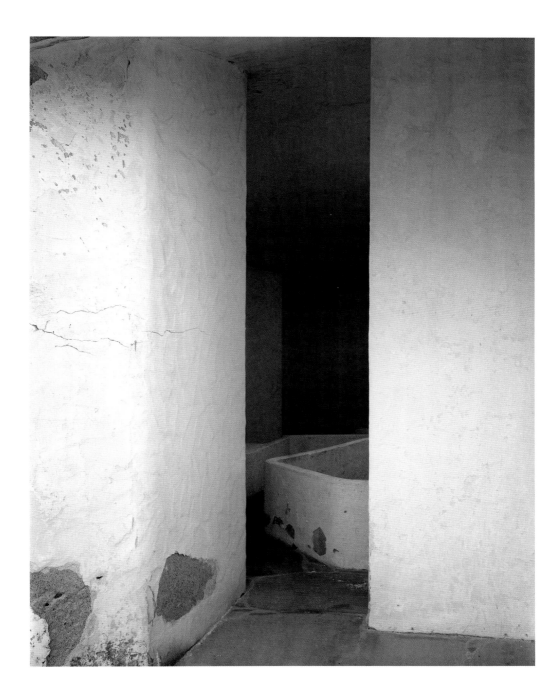

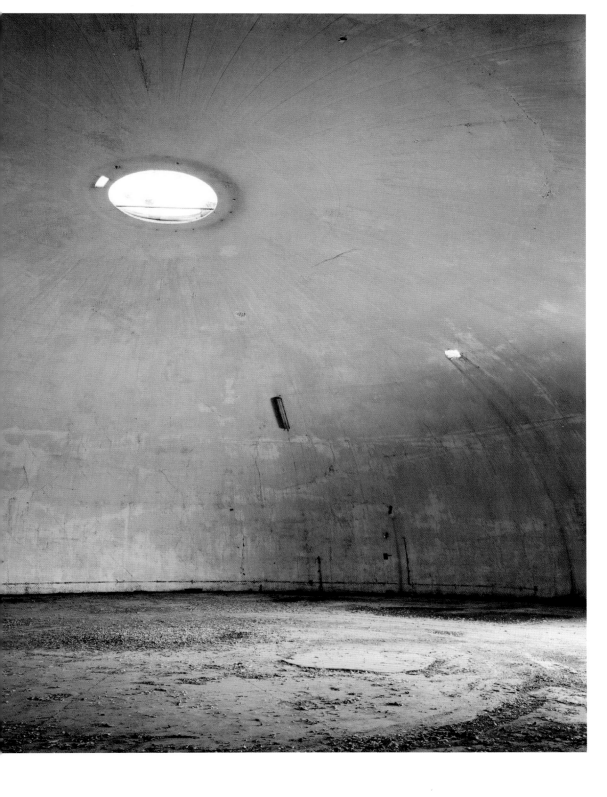

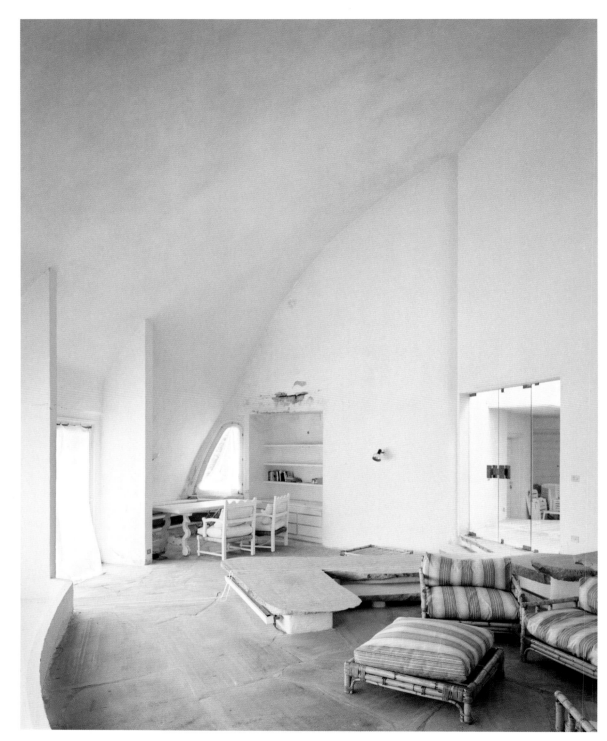

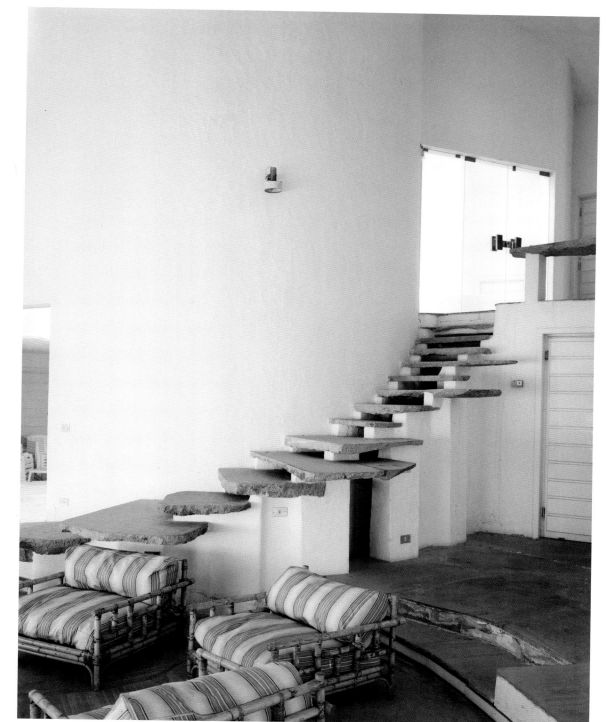

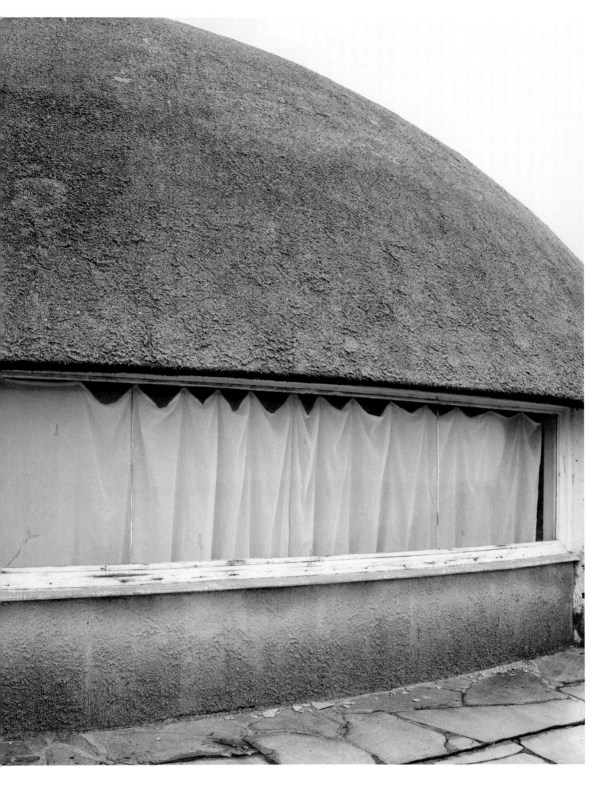

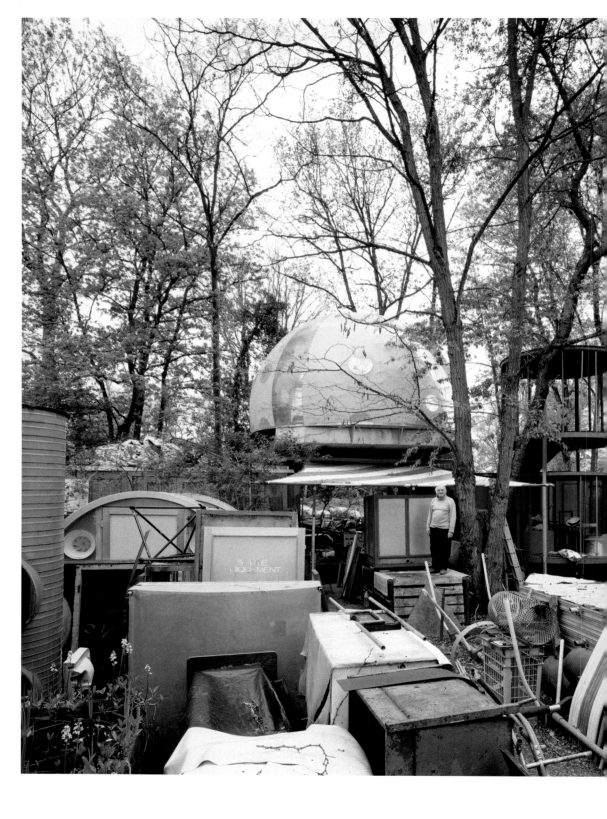

Hans Walter Müller

To visit Hans Walter Müller, you have to exit the Bordeaux motorway south of Paris and drive down a few narrow country roads. At the end of an airstrip, you see the apron of an old military airfield. Parked on the left in front of a wooded piece of land is a rusted old Renault Saviem and, beyond it, there are yellow shapes shimmering through the bushes: this is where Hans Walter Müller has lived since 1971. Depending on how you view it, his dwelling is either very small or huge. Indeed, there is a giant inflatable membrane arching above a hole in the ground as large as a three-bedroom apartment. To access the hall where Müller lives, you have to go through a yellow airlock; in fact, you have to squeeze your way through what looks like a pair of giant vertical rubber lips. There is an old Honda engine humming away to maintain a constant excess pressure. Whenever it fails, the spacious hall that Müller lives in with his wife collapses around them. It does that, too, whenever it has snowed heavily, which, as Müller tells us, is something that has happened in the past. His house then becomes very small indeed, i.e. just the hole down below in the rock face, beneath the ground, to which Müller has dug a small side entrance. Life here is like that of a mole's inside its tunnel, but among plants and books. A staircase leads up into the hall, which is anything but that: the sun shines through the translucent membrane, and you find yourself at the very heart of nature, but shielded from it nonetheless by a light film of plastic. Müller has been living like this for more than four decades. When he moved in, people thought he was insane. Who could live inside a plastic bag?

Müller showed that it was possible. He built his inflatable hall, which is also his workshop. And it is here, to this day, that he still has the strips of plastic for his yellow-transparent inflatables cut to size and welded together. Müller was born in Worms, Germany, in 1935, and by the time he moved here he was already a well-known member

of the architectural avant-garde. He studied architecture in Darmstadt, graduating in 1961, but it was in Paris first and foremost – where utopians like Yona Friedman were teaching and artists were working on "kinetic art" – that Müller found the ideal climate for his works. He worked on light and photographs/slides, on dissolve and fading effects; he experimented with electric motors to see how they might support an "architecture in motion", with building houses that could breathe. His first artistic works went on show at the Biennale and at Frei Otto's legendary pavilion at the World Exposition in Montreal. But Müller was not content with designing kinetic machines as artworks. He was serious about the old idea put forward by Gottfried Semper that architecture was merely a second layer of fabric that people put around them like clothing.

1

For many architects of the day, one of the main motivations for experimenting with inflatables was that it was better to build a world that is shut off from the environment, from exhaust fumes and industrial pollution. When Ant Farm (the experimental Californian architecture commune) began printing instructions for its own inflatables – the famous *Inflatocookbook* – and its members walked around in helmets, it was also an ecologically motivated critique of a society prepared to sacrifice its life fundamentals on the altar of industrial growth – and more.

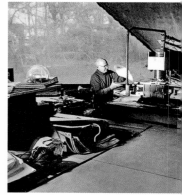

2

What made inflatables so attractive to architects at the height of the massively brutalist modernist age of concrete was their lightweight, spontaneous and versatile qualities, first and foremost. The construction method itself was also resource-friendly.

In 1969 Müller built an inflatable church at Montigny-lès-Cormeilles north of Paris. It weighed 32 kg in its deflated state; it was capable of accommodating 200 people and could be set up anywhere, lending an unexpected avant-garde reality to the religious metaphor of the congregation as a ship that sails around the world. The entire church was lighter than a sail.

Müller was designing his inflatables at a time when the Vienna architecture actionists of Haus-Rucker-Co were unsettling public spaces with their "pneumatic cells". The *Gelbes Herz* (Yellow Heart) looked

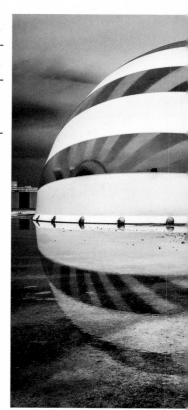

like the pulsating organ of a "psychedelic animal"; in essence it was nothing other than a bed surrounded by inflatable materials that you got into through an airlock. It was set up at the bottom of the construction pit for the new police headquarters in Vienna in 1968, which meant it was also a "dig" at the rigid notions of what is permitted in the public space and what isn't.

Reyner Banham and François Dallegret's *Environment Bubble* and also *Oase Nr. 7* by Haus-Rucker-Co had similar objectives in mind. It made its appearance in Kassel's public space at documenta 5 in 1972, as if someone had inflated a giant bubblegum into the space behind the colonnaded façade of the Fridericianum. A see-through bubble you could sit in or doze in far above the city inside a human-sized soap bubble, prominently visible and yet detached from the crowds below.

Müller countered the hedonism of these "fun bubbles" with more serious intended uses for his inflatable habitats. In 1975 he manufactured 35 inflatables for homeless people, all of which were distributed during one freezing cold night in February. Countless other inflatables for museums and theatres followed, for example the inflatable theatre for the Olympic Games in Barcelona. And yet, gradually, people forgot about Müller – until younger artists like Tomàs Saraceno and architects like Plastique Fantastique and Raumlabor revisited the idea and Müller's key themes: does it take a solid building to create a venue or would a mobile structure be conceivable, one that embeds itself temporarily somewhere and creates space wherever it appears, like the *Küchenmonument* (Kitchen Monument) that the Berlin architects collective developed together with the specialists at Plastique Fantastique for the Akzente cultural festival in the Ruhr district. Excess pressure is used to inflate a transparent bubble out of a container, with the bubble, accessed through an airlock, providing space for up to 80 people to dine or dance, etc.

Initially, the container was set up as a sculpture at inhospitable locations, such as beneath a motorway bridge, or in a run-down park. The pneumatic monument simply inflated its way into the city, like bubblegum. Thanks to its shape, it did not clash with the existing housing stock,

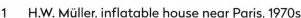

1 H.W. Müller, inflatable house near Paris, 1970s

2 H.W. Müller, inflatable house near Paris, 1970s

3 H.W. Müller, pneumatic structure, 2015

but simply nestled up to trees, pillars and buildings – and then disappeared without a trace afterwards.

Passers-by were irritated by the fact that there were food odours coming out of the artwork – and then, suddenly, it would exhale its bubble, growing energetically and noisily as it filled with air, and then snuggle into empty spaces and up against façades, lanterns and trees. First a banquet for the entire quarter was organised inside the transparent space: "the postman, the kiosk owner, and the Gürel family from the third floor of the neighbouring building all became cooks and hosts alike", said the architects. After the meal, the bubble disappeared as quickly as it appeared. The object continued on its travels and became the *Ballsaal Ruhrperle* (Pearl of the Ruhr Ballroom); this time, dance music came out of the box. Then the box continued on its way, again transforming the city into a public kitchen. The classic either/or of the contemporary European city – either behind thick walls, i.e. on the inside, or out in the public square, i.e. outside – was dissolved. A membrane creates an open, weatherproof, mobile intermediate space that wanders through the city and is multi-purpose in its function.

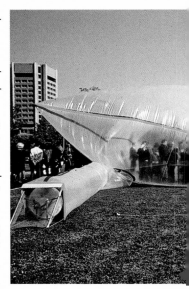

The transformation energy of the pneumatic urban machines that Müller and his students build is quite astonishing. Once inflated, they even manage to turn a motorway bridge into an attractive venue; guests sit inside the bubble as if in a space ship and, through the protective membrane, they look out at the city as if it was the hostile, oxygen-deprived environment of outer space. At the same time, it becomes the hallmark of a different notion of the city, especially at night when it's illuminated and depicts its occupants as half-shadows.

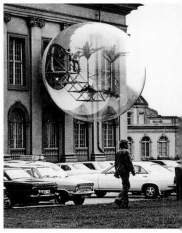

The membrane creates an open, weatherproof, mobile intermediate space that wanders through the city and is multi-purpose in its function. What emerges inside these bubbles is a different notion of what architecture can be: not something static, built for all eternity, inflexible and expensive, but something dismountable, mobile, a stage that is as open as possible to all types of purposes, not just as a pop-up restaurant, but as temporary accommodation, as a membrane that separates the sleeping place from its environment. It is also about a political deconstruction of the systems that shape building practice and

5

4 Ant Farm, *Clean Air Pod*, Berkeley 1970

5 Haus-Rucker & Co, *Oase Nr. 7* at documenta 5, 1972

6 Haus Rucker & Co, *Das gelbe Herz*, 1968

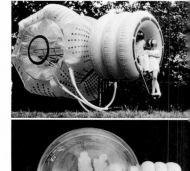

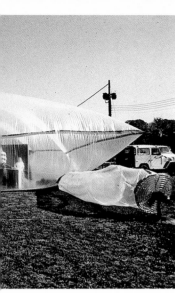

urban planning. Who decides how the public space is designed, how it is built, what materials are used, and in what forms public life can take place? These are all questions that the pneumatic monuments raise, which Müller continues to work on, inside his own inflatable hall, south of Paris.

4

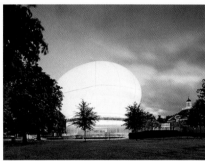

8

7

7 Rem Koolhaas/OMA, Cecil Balmond, *Serpentine Pavilion*, 2006

8 Raumlabor, *Küchenmonument*, Berlin 2006

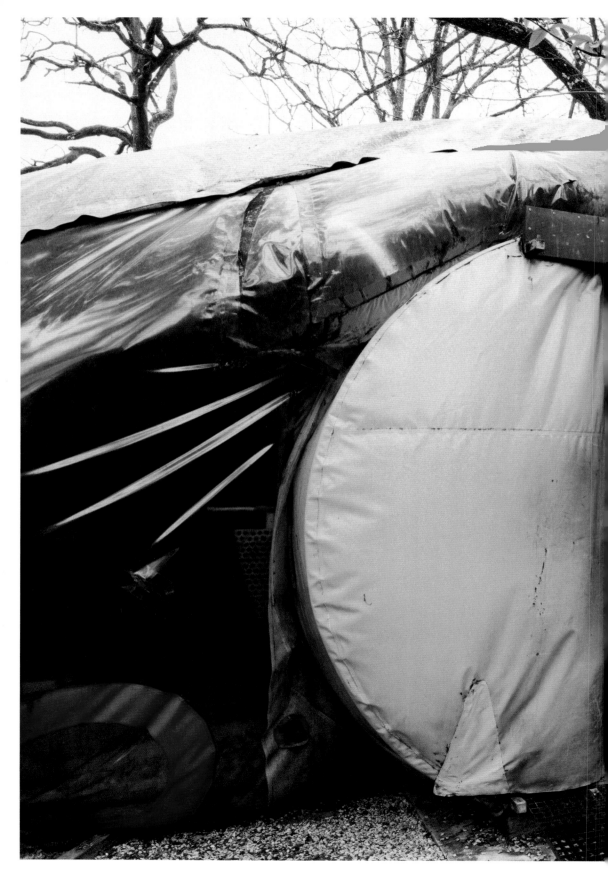

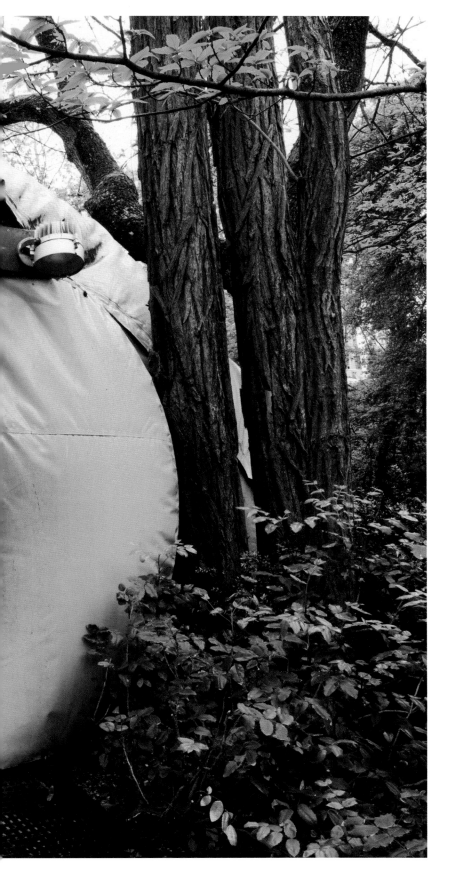

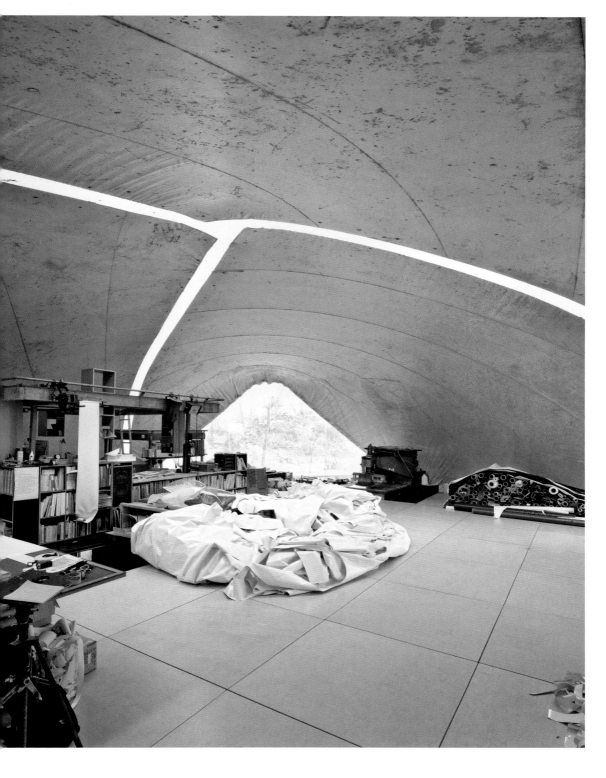

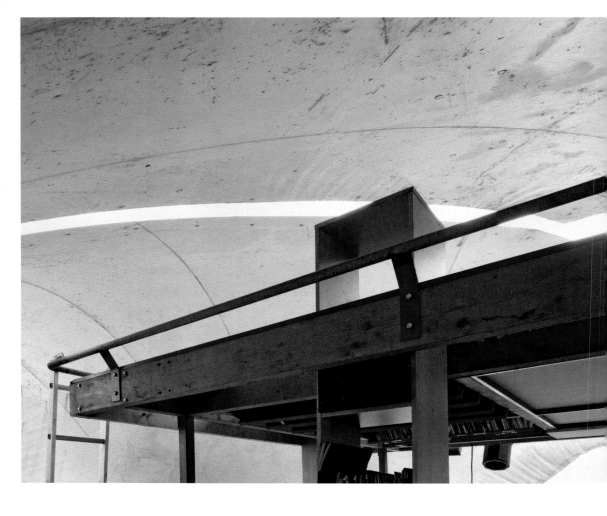

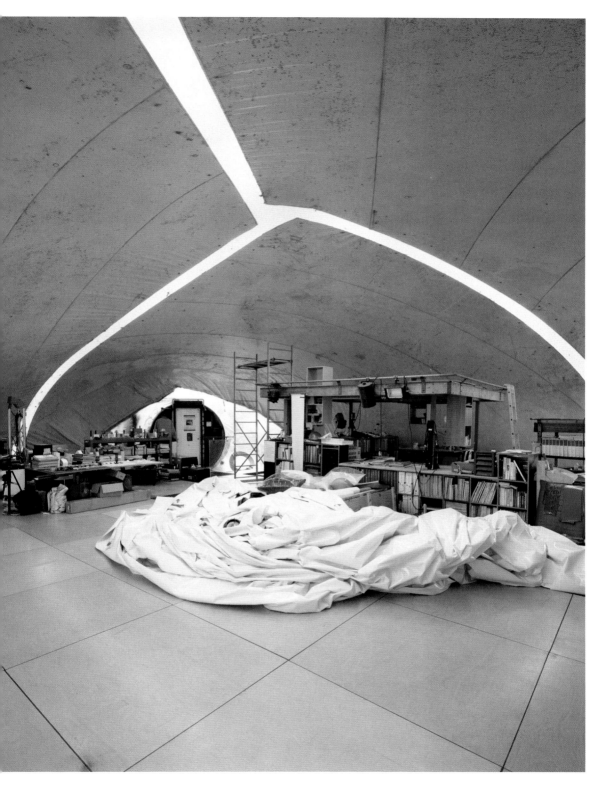

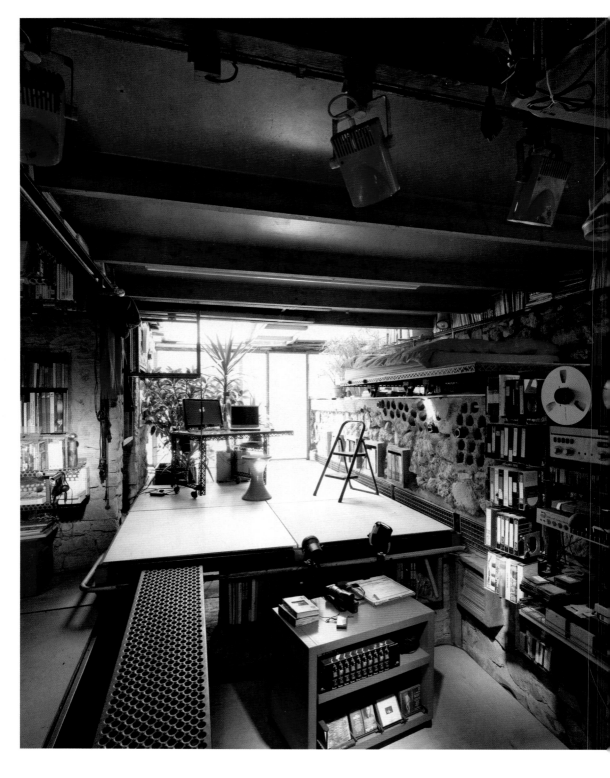

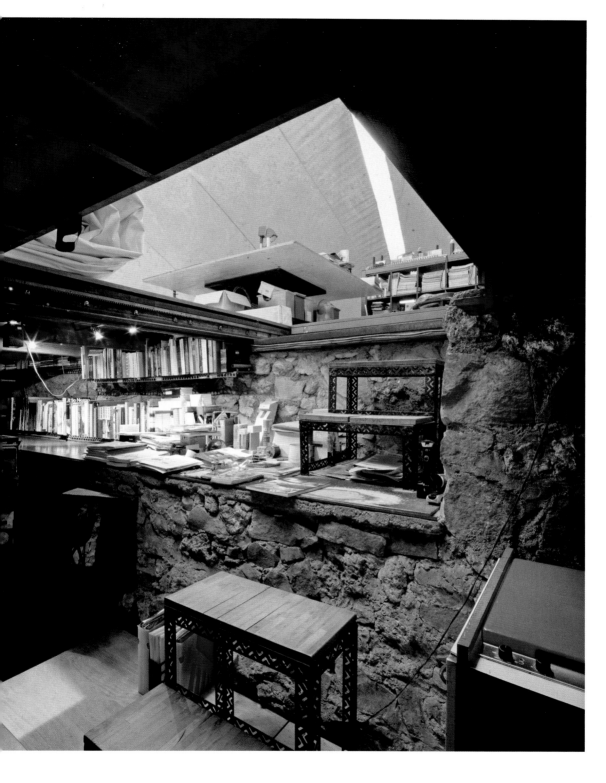

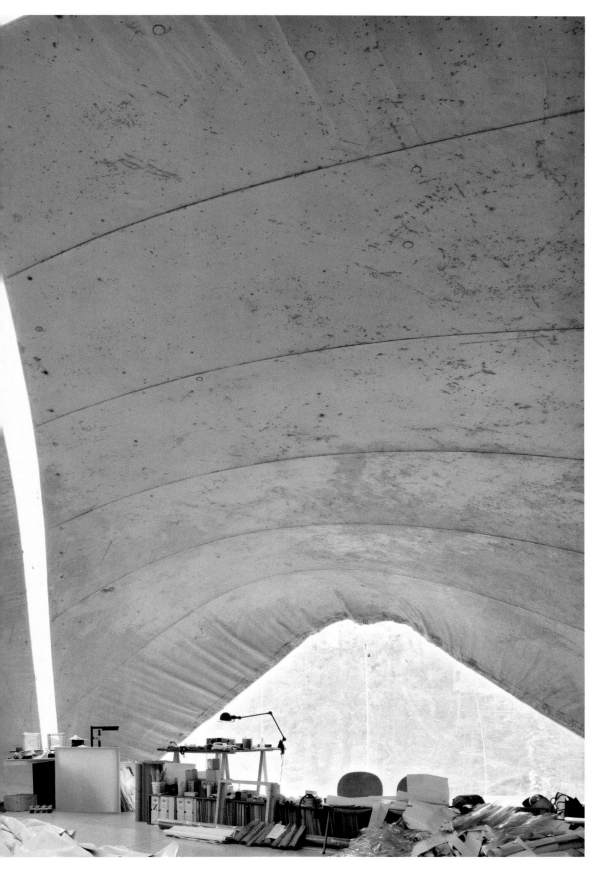

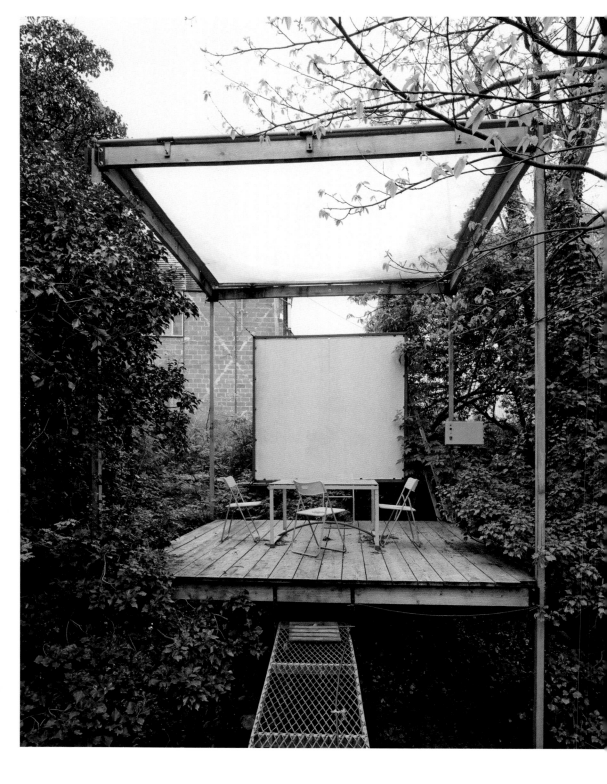

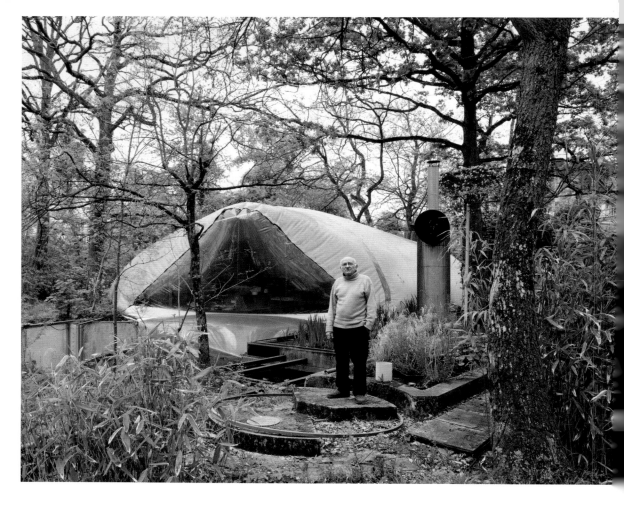

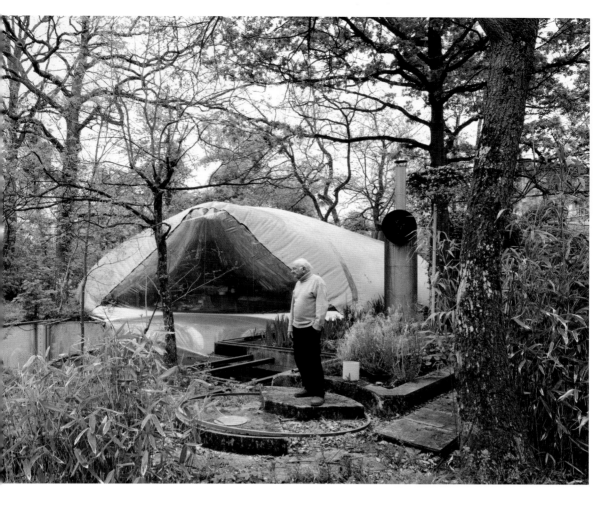

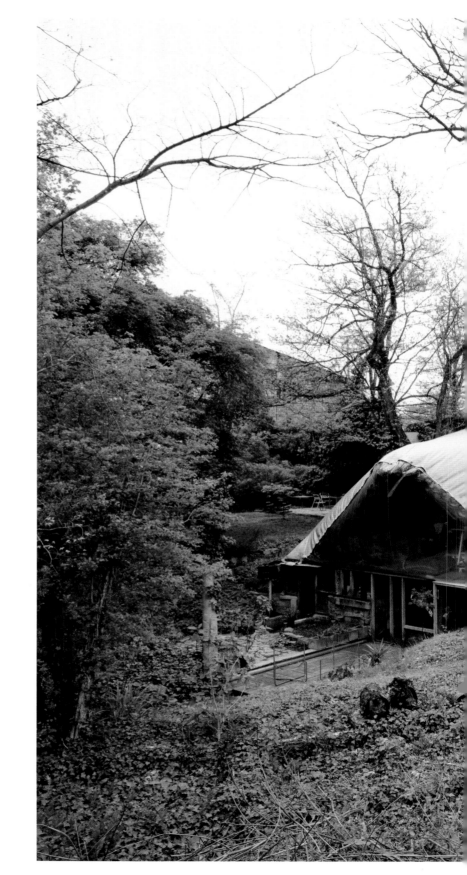

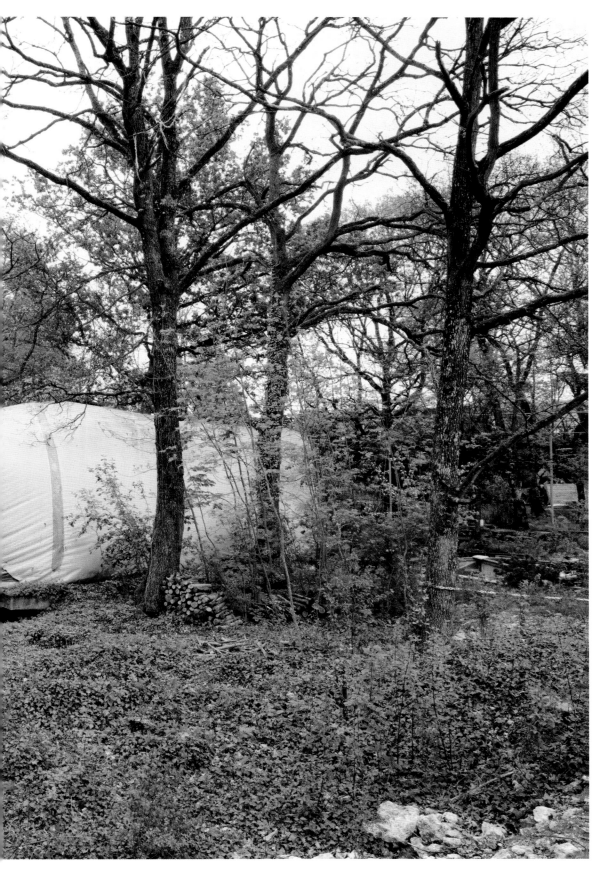

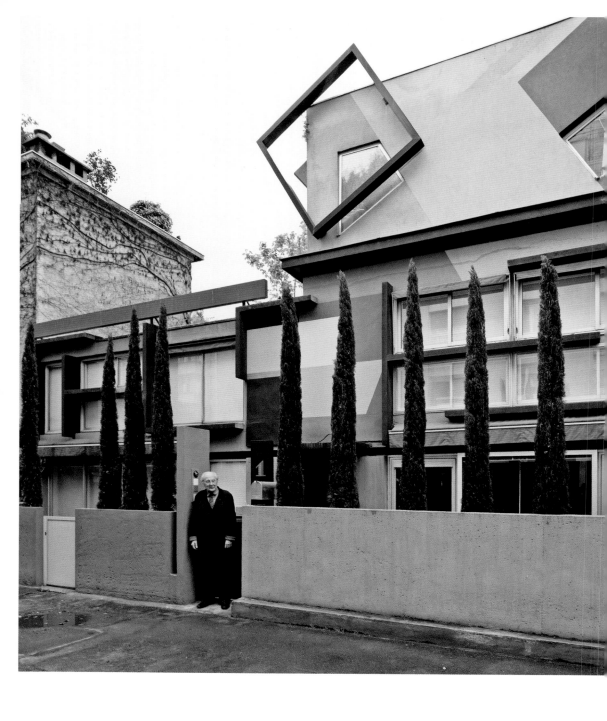

Claude Parent

From the outside, the small grey villa located in a side street in the west of Paris, near the Bois de Boulogne, looks almost like any other ordinary house from the 1960s. Only the strangely tilted windows discernible beyond the thin, rigidly upright cypress trees hint at the fact that, inside, things may be a little different from what's in neighbouring houses. The villa was once Claude Parent's house; it's where his family lived. His daughter has written a wonderful account of life inside this building, where the architect born in 1923 wanted to start a revolution. It was impossible, for instance, to put any furniture anywhere: hardly any of the floors were level.

The house was an experiment that Parent conducted to find out what happens when you remove from a house your starting point as a draughtsman, i.e. level floors, level foundations, and then everything you normally associate with a living environment, i.e. the doors, the corridors and, above all, the furniture.

The Parent family had almost no furniture; in fact, most items of furniture had been banned from the house, and so the family lived on inclined ramps laid with a dark carpet. They ate in a reclining position; there were triangular table-like objects so you could at least put a cup down while you were lounging about; other than that, anything that might conceivably be considered as furniture disappeared completely from the living room.

Recessed into the angles, and invisible to visitors, were soft cushioned islands you could sink into, like nests. Parent's daughter describes how baffled her girlfriends' parents were whenever they called in the evening to pick up their children and had to enter the house; how they were knocked off balance; how they would search in vain for a chair to steady themselves; and how they would then collapse onto the inclined floor, as if it was a swamp made of velvet: "You would lie on plateaus and in caves […] and visitors would often shriek in horror whenever they stepped

onto one of those soft spots", wrote Chloé Parent. The children were thrilled by this life *à l'oblique*, as it were. And Claude Parent hoped for a revolution: that social relations, the dynamics between people, would change in favour of something wilder, better, more exciting and less formal if only you could pull the level floor from under their feet and the rigid chairs from under their behinds. His wild world of ramps was modelled on the spirit of the Roman feast; his ideal was not the formalised dinner seated at high-backed wooden chairs after which diners would retire to the comfort of a seating area, but rather a wild, lounging disarray. There is an old photograph of him from the late 1960s, seated on one of his inclines, with a long beard and long hair, like a disciple: a prophet of the new vision of home living without furniture.

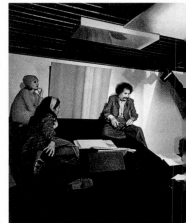

Back then, when he was the darling of the Parisian habitation utopians and disseminated his *Architecture principe* with his friend Paul Virilio, he already had a successful career as an architect behind him. It was Claude Parent who, in the 1950s, brought the Californian modernism of Richard Neutra and Craig Ellwood to France. He built the sort of villas that would be lampooned in Jacques Tati's film *Mon Oncle*: ultra-modern glassy symbols of the future, like the Maison G, which he completed outside Paris in 1952 with his colleague Ionel Schein, or the house for the artist André Bloc. Together with Yves Klein, he invented a pneumatic rocket and, without him, a car that looked like an insect with wheels instead of legs. If all these experiments had a common trait, it was a deep-seated unrest, a desire to inject new momentum into the status quo, to upset and disrupt.

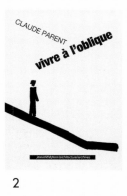

2

Parent was already a wealthy modernist by the time he discovered the Second World War bunkers constructed in the sand dunes along the Atlantic coast during his excursions with Paul Virilio. The philosopher Virilio was a childhood friend who had acted as an intermediary for his first building contract, a renovation project at the Lourdes pilgrimage site. Over time these Atlantic bunkers had begun to subside and sink into the sand, literally undermined by the severe winter weather. Together, the architect and the philosopher crawled into these slanted ruins. As the story goes, they then apparently found themselves in rooms where notions of "ceiling", "wall" or "floor" were meaningless. The dark, slant-

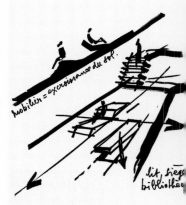

1 Claude Parent in his living room in Paris, *c.* 1970

2 Claude Parent, *Vivre à l'oblique*, book cover, 1970/2004

3 Claude Parent, draft for a living space with reclining seats, undated

3

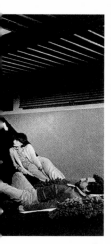

1

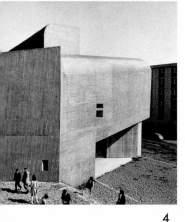

4

ing room created a sense of dizziness not even the most turbulent Baroque church could achieve. Parent changed his style. With Virilio he co-authored a pamphlet entitled *Vivre à l'oblique*. In 1966 he built the Church of Sainte-Bernadette du Banlay; with its sloping floors and thick brutalist concrete walls, it is certainly reminiscent of a bunker. He was also a strong advocate of life without furniture. With Virilio, he drove around Paris in a jeep with the words *Architecture Principe* inscribed on it: two Allies joined in the battle to liberate us all from an orderly furnished life.

"Just think how boring our homes are", he told us the first time we visited him in his small apartment in Neuilly, where he was living after selling his villa. "The children sit around the playroom. The man of the house sits around on his inherited sofa. We're completely over-furnished. Why can't we adopt a more playful, freer approach to space? Why can't moving around that space also mean climbing, lying, sliding?"

Around 1970, when he transformed the French Pavilion at the Venice Biennale into a slanting, sloping landscape, Claude Parent was widely regarded as the visionary of a new lifestyle culture, as someone who was pioneering the implementation of the philosophical idea of deconstructivism into building practice – by deconstructing the very concepts in which architecture had been conceived and, indeed, conceptualised, disassembling them, and then reassembling them. A "floor" could now also be "furniture"; a notion of spatial thinking emerged that went beyond 90° angles. And Parent did not restrict to home interiors his idea of a society rendered more dynamic, less hierarchical by the oblique. For the Plateau Beaubourg competition in 1970, he tried to use oblique lines to remodel the urban landscape, the public space, too; in 1971 he drew up his plans for La Colline, an entire town comprised of oblique surfaces; in 1973 he published his tract entitled *Habitat oblique*.

So why is it that Parent remained forgotten for so long? Why did it take an exhibition in Paris for a wider audience to rediscover him, at a time when he was well into his eighties? Perhaps it had something to do with the fact that he didn't just make friends among his anti-capitalist fellow campaigners when he turned up in one of his luxury sports cars (preferably a Lamborghini or a yellow Maserati), sporting a pair of yellow bell-bottoms and a pair of narrow white leather shoes (as his student Jean

5

4 Claude Parent, Église de Sainte-Bernadette du Banlay, Nevers, 1963–1966

5 Paul Virilio and Claude Parent in their *Architecture Principe* jeep, 2000

Nouvel once said, "no one is ever going to outbid Claude Parent in an elegance contest"). Two contracts he took on in the 1970s represented a fall from grace for which the architecture scene never forgave him. One was the design for the buildings of the Goulet-Turpin supermarket chain owned by his wife's family, who had opened France's first supermarket in 1948 as well as the country's first self-service stores. In the 1960s they were leaders in the construction of so-called hypermarkets based on the American model. Parent designed these supermarkets as a sort of Atlantic Wall of consumerism in the hope that consumers would extrapolate from the quality of the iconic concrete architecture to the quality of the products themselves – a miscalculation, as it soon transpired. The rivalry of the Carrefour hypermarkets with their architecture-free concept carried the day. They had opted from the outset for vast cost-effective hangars with large logos and a pragmatic low-cost visual aesthetic that held the promise of affordable prices, first and foremost. Euromarché took over the hypermarkets of the Goulet-Turpin chain in 1979.

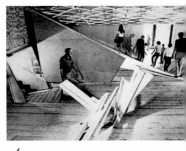

6

For a left-wing architectural scene, Parent's decision to design the Cattenom and Chooz nuclear power plants was even more unpardonable. "No-one at the time was thinking about nuclear waste or about the hazards; it was simply a wonderful new technology", said Parent when we asked him about it. After the nuclear power plants it all went quiet around Claude Parent.

He closed his offices in the mid-1970s. Thereafter, his main influence on a new generation of architects like Jean Nouvel was as a professor. In 1991 he did design the Théâtre Silvia Monfort in the 15th *arrondissement* of Paris, a building moderately Japonist in style. But with the exception of the gallery that winds its way around the hat-like roof, there is little there to evoke the "theory of the oblique".

Parent worked for developers, sold his house (whose new owners promptly ripped out all its ramps), and moved into two apartments in Neuilly where he installed what remained of his "oblique world". There the greatest extravagance was a free-standing bathtub and an equally free-standing toilet – so whenever a guest needed to use the toilet, Parent and the other guests would patiently wait outside in front of the door.

It is only in the last few years that we have come to realise how important and revolutionary his thinking was, and still is, for a new archi-

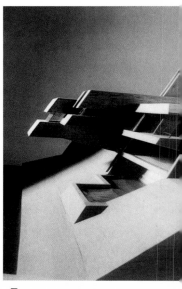

7

8

6 Claude Parent, French pavilion at the Art Biennale, Venice, 1970

7 Claude Parent, model of a house on a slope, undated

8 Claude Parent, G.E.M. superstore, Reims–Tinqueux, France, 1970

tecture that goes beyond conventional notions, categories and ideas that otherwise determine construction. Ninety-nine per cent of all architects are commissioned to build four-storey houses, stacking four boxes roughly four by three metres on top of one another and then connecting them with staircases. But often the propositional speech act of "four floors" only means that a house or building cannot exceed a maximum height of some 18 metres. With his ramps Parent demonstrated what happens when an architect deconstructs the notion of the "building floor" or "storey" – as Sou Fujimoto did, someone who in his ability to break down the conceptual categories of architecture is arguably a follower of Parent. At his *NA* house in Tokyo, Fujimoto managed to incorporate more than 20 levels linked by small staircases consisting of two to three steps each, instead of four storeys roughly the same size. As a result, the family life of the building's occupants is organised in a completely different way. Here work on the concept preceded work on the form; the freedom of design resided in the ability to lever out and reformulate an unquestioned category regarded as a given. Just as Parent built his ramps, the Japanese SANAA offices in Lausanne also built an entire university campus as a sort of dune landscape consisting of oblique floors, a breach with convention designed to extend to the teaching and the learning – that, too, a form of architecture that would have been inconceivable without a "theory of the oblique". Claude Parent died in Neuilly-sur-Seine on 27 February 2016, a day after the celebrations marking his 93rd birthday.

9

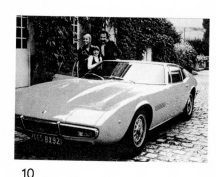

10

9 Claude Parent, drafts for a nuclear power plant, 1975

10 Parent with his family and his yellow Maserati, early 1970s

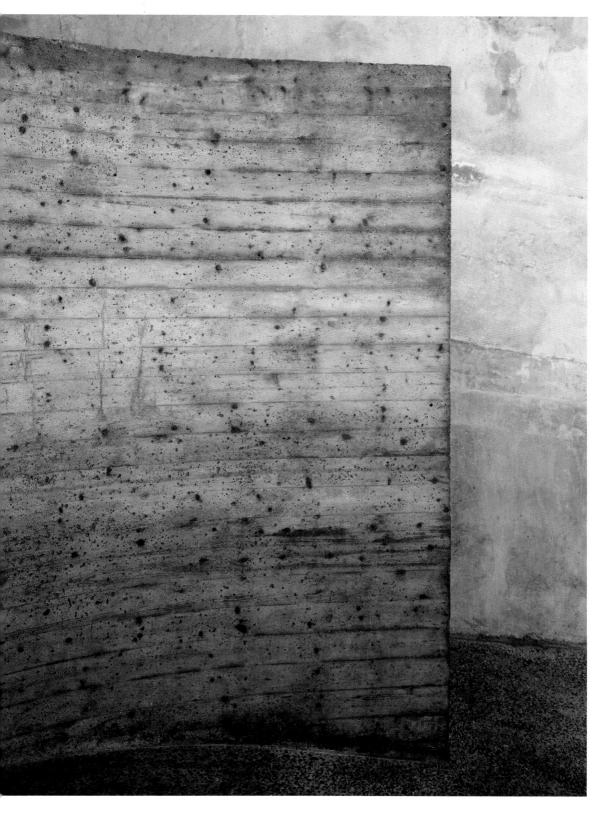

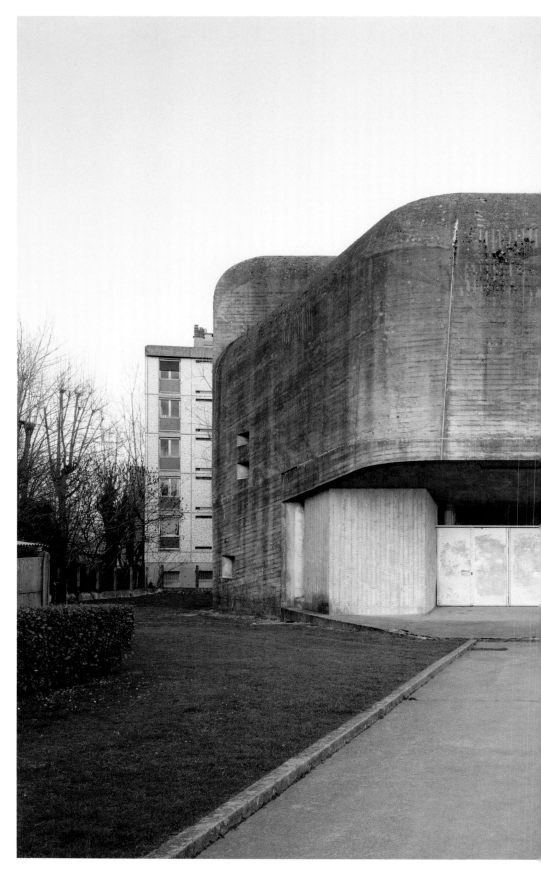

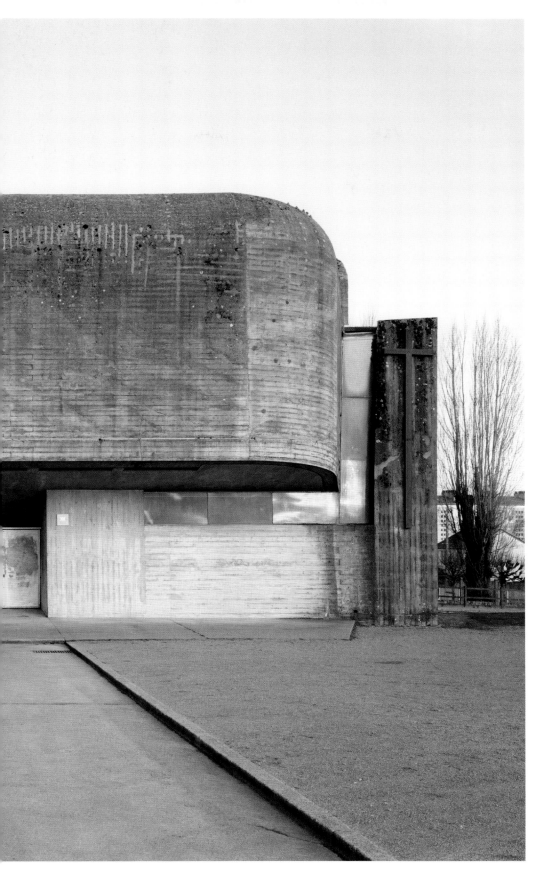

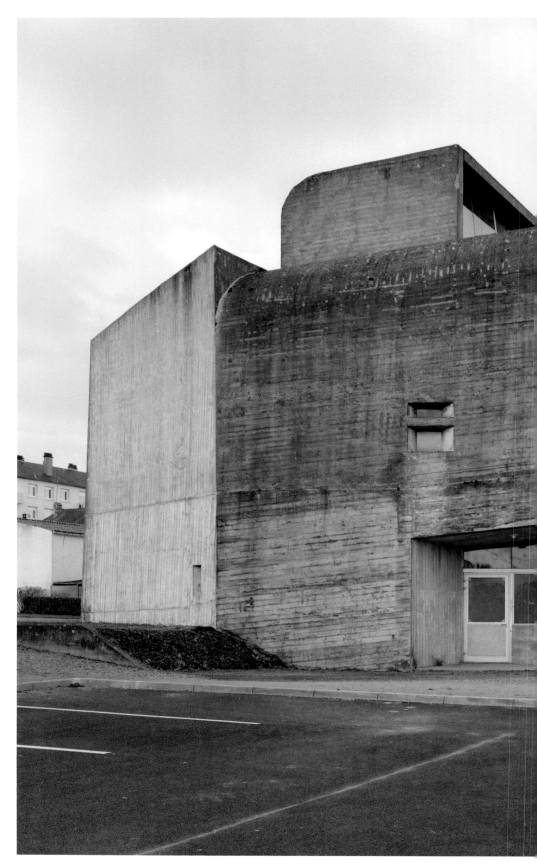

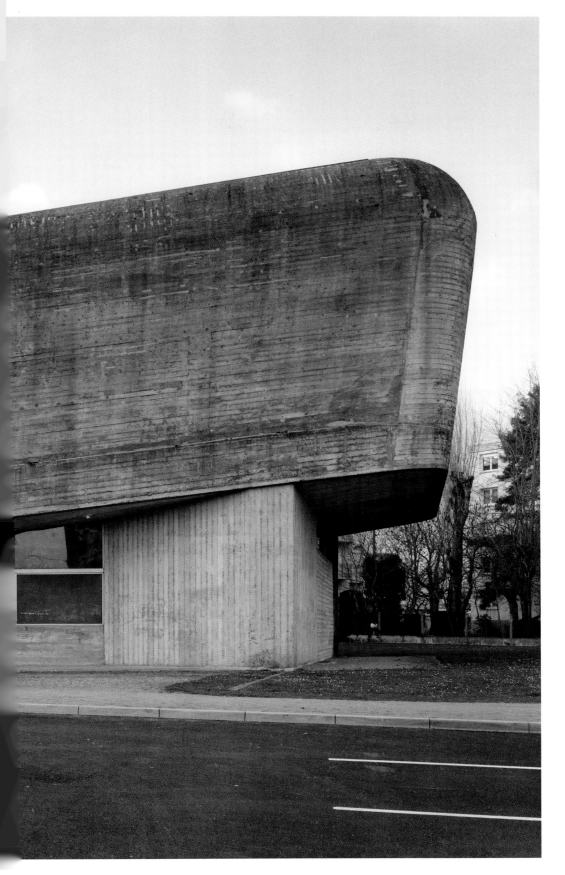

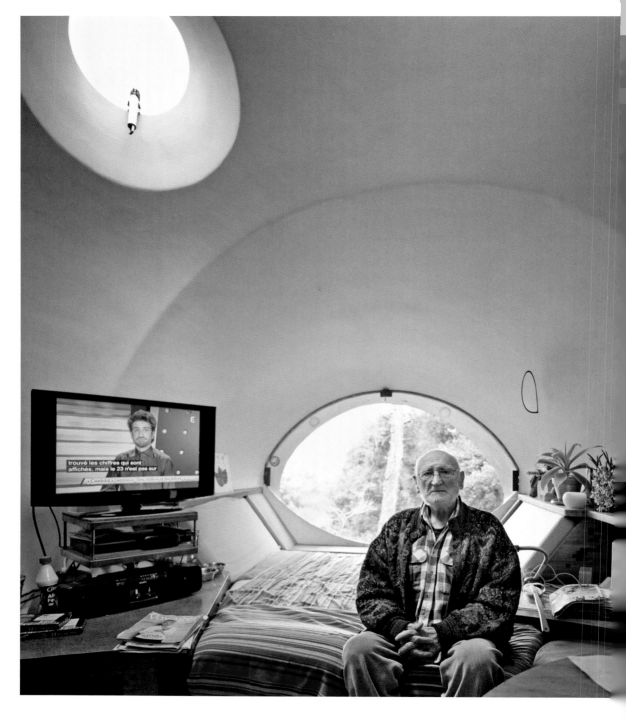

Antti Lovag

The first time I visited Antti Lovag, in 1999, the house he had been working on for three decades was not finished. Part of it was still under construction, and part of it was already a ruin. It looked like it had entered a bizarre time warp: concrete mixers were lying around the back, rusting in the grass; the wildly proliferating copse of oak trees was encroaching on the spherical plastic windows, gradually blinding them in the process. But the front of the house with its rough concrete bubbles looked as if it had just been completed, and standing expectantly in the forest clearing were a couple of cranes, and a couple of trucks, their tyres deflated. So while one end of the building was already projecting into the future, the other was sinking into the luxuriant natural setting, the ivy entwining its tendrils across the flaking paint. Clearly, building work had ceased some time ago, yet the building site had not been abandoned.

The house under construction was huge, and it looked nothing like any of the residential properties ever built along the Côte d'Azur. It offered approximately 1,200 m² of living space, perhaps even 1,600 m², depending on how you measured it, but in any case it was hard to calculate, given that not a single cubic metre of the property was square-shaped. And was the jungle of palm trees growing inside the house and the genuine stream flowing right through it down marble steps still part of the building's interior?

Before you could even catch sight of this spherical dwelling up on the high plateau of Tourrettes-sur-Loup, with its concrete bubbles and its large portholes, you had to hike your way up a trail that led through boulders and pine trees and a small forest of oak trees. And scattered about that little forest, like in an enchanted landscape, were the strangest of things, all overgrown and literally perfoliated: overgrown spheres of steel, cement mixers, wire mesh, cement *bozzetti*, windows – it all looked like the aftermath of some gargantuan architectural revelry. Some of the concrete components had rolled down the slope, and a couple of twisted

rebars had become overgrown with trees. It would have been impossible to demolish Lovag's field of experimentation as it was now fused with nature itself, a dense meshwork of rejected ideas, burdock, and roots. In fact, it looked as if the prototypes had actually been grown there, rather than built there: the forest itself was a prototype.

These remains were the legacy of an experimental building commune that lived here, on the rock karst in the hilly hinterland above Nice and Cannes, between 1968 and 1980. Antti Lovag told us that up to 40 people had worked there with him on something he didn't call architecture, but "habitology", i.e. the science of home living. It was meant to be a new form of habitation, one that wraps itself around its occupants like a living, intelligent envelope, rather than a rigid cardboard box. Lovag did not want to be the *architékton* – from the Greek ἀρχή (*arché*), i.e. the beginning, the command, and τέχνη (*téchne*), the technique and its execution – but a habitation scientist: someone who rolls steel spheres through the land unconstrained by plans or directions, reassembles them anew, then fixes them with concrete, but always in such a way that they can be complemented, rebuilt, and demolished. The house should react to its occupants like a living organism and be capable of altering its shape accordingly, allowing elements to embed themselves.

Antti Lovag said it was like a cathedral workshop that they had erected there, except that they had no intention of building a cathedral, but a gigantic shell for a new way of life, a building without angled walls, just a jungle and a pool and a couple of bathrooms and lots of bedrooms, a model for what life might look like once civil society had come to an end. The building commune had worked on this world of spheres until 1980. Then the client (the financial speculator Antoine Gaudet) lost interest in the project. The people who had worked on Lovag's small building commune went their separate ways; the grass and the palm trees and the bushes proliferated around the prototypes and all over the building site. Lovag was unemployed, and for someone who only builds bubble houses, the early 1980s were the worst moment in the history of architecture. He decided to move into one of the hut-sized models they had built in preparation, a prototype for the big house, a construct reminiscent of an octopus tentacle that looked like it had crash-landed straight

1

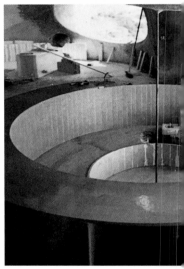

2

1 Antti Lovag, Tourrettes-sur-Loup building site, *c.* 1970

2 Antti Lovag, prototype, Lovag dwelling under construction, undated

3 Antti Lovag and Pierre Bernard, *c.* 1970

out of the future onto this rock karst outside Nice. He would live there until his death. Antti Lovag was the only architect in the world I ever knew who, for more than 30 years, lived in the model of the house he actually wanted to build.

By the time we met him in 1999, Lovag had almost been forgotten. His house consisted of a single oval room, with a bed floating on top of a concrete bubble. There were no straight walls and no façade. In the main room, a folding table dangled in front of a seating area; in the corner stood a stove, with a dog dozing below it. And sizzling in the hot fat of a heavy steel frying pan were three chops. It smelt like an ancient charcoal burner's hut. Nowhere did the ultra-archaic and the ultra-modern collide as bizarrely as in Lovag's bubble, which, as mentioned, was actually nothing other than a walk-in model of the building that had been under construction nearby on the karstic hill since 1968.

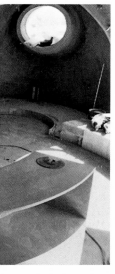

Lovag was born in Hungary in 1920. He was 48 by the time he was commissioned by Antoine Gaudet and his young girlfriend, an art student, to build an entire world of bubble houses on the rock karst near Tourrettes-sur-Loup in 1968. We are now seated by the fireside; outside, the mistral is wresting pine cones from the trees. "What had you been doing before that? How did you end up in France?" we ask.

As an architect, Lovag was a superb inventor, but he could be just as creatively inventive with the truth. No one will ever be able to reconstruct what actually happened during his life between 1920 and 1948, a time when he still went by the name of Antal Koski. Anyone you talk to about Lovag has a radically different story to tell.

On our first visit, Lovag told us that his mother had died in unexplained circumstances shortly after his birth, when he was around seven months old. Lovag said it was an assassination: he believed she had been killed by her anti-Semitic family, who could not bear the thought of an illegitimate child born to a Jewish engineer. He and his father then fled to Turkey, where he began building Izmir's first cinema theatres. In 1924 he went to Finland, again to build cinemas. When Finland entered the war in 1939 to fight against Russia, he joined the Finnish armed forces as a pilot. In the middle of the war, he absconded to Lithuania to look for his father, who had fled there from the Germans. Antti was arrested

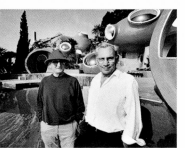

3

by the Russians, but posed as a Finnish Jew forced to flee the Germans, a story they believed. In 1945 he entered Berlin alongside the Red Army and made his way back to Scandinavia (an alternative version he told us on our second meeting was that, when the Russians marched into Berlin, he met the Swedish ambassador's daughter and travelled with her to Stockholm; the next account, on our third meeting, was that he met the Swedish ambassador in Berlin and went back to Stockholm with him, where he then met the latter's daughter). In any case, it was in 1946 – according to Lovag – that he inherited his father's estate after the latter's death. He bought a yacht and was planning to spend his 26th birthday circumnavigating the world.

By December 1946 he had reached the Seine estuary – and he remained in Paris. He spent his time at the École des Beaux-Arts and made the acquaintance of the designer Jean Prouvé and worked for him from time to time. Together with the experimental architects Pascal Häusermann and Jean-Louis Chanéac he founded the group *Habitat évolutif*. Their concept of architecture was shaped by Frederick Kiesler's theory of correalism and his organic *Endless House*, a model of which went on display at New York's Museum of Modern Art in 1960. The building's organic shape was to be created by covering a free-formed steel mesh in concrete, thus providing the transition from simple Euclidian geometry to a more complex spatial design that looked more like a second skin or an extension of the human body; its occupants would then be able to pass through it like blood cells flowing through a vein. Like Kiesler, Lovag dreamed of spaces that were like body imprints, of the identity between building structure and physical anatomy.

Lovag built the first such structure in Théoule-sur-Mer in the south of France, next to the Port-la-Galère residential complex designed by his friend Jacques Couëlle, where he built 26 residential bubbles for the industrialist Pierre Bernard. Soon after, again for Bernard, he designed the Maison Bulle, a mix of residential dwelling and communication centre that was later bought by Pierre Cardin. This particular structure already reflects Lovag's great inspiration, namely Charles Fourier's *phalanstère*, or phalanstery, a large-scale self-sufficient 19th-century utopian community, a residential complex for 1,600 people based on the floor plan

Ferraillage sur gabarits en Poutrafil

Le ferraillage est disposé en deux nappes. L'une suit les parrallèles, l'autre les méridiens.
Certains méridiens sont interrompus avant le sommet pour éviter une trop grande densité de fers en partie haute.
Les Poutrafils garantissent la régularité de courbure.

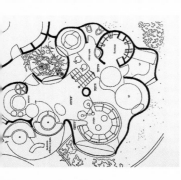

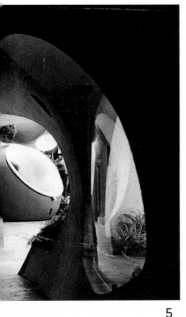

5

of the Palace of Versailles. The main wing would accommodate the collective dining room and the library, as well as a conservatory. Fourier was obsessed with the idea of cancelling out the seasons, with being able to be outdoors at any time, even when you were indoors, an aspect also to be found in Lovag's work.

With Fourier, the architecture designed for the collective community was not restricted to formal measures; in Fourier's architectural dream, the human body, too, would be beyond the reach of privatisation. Free love was a key component of his theory, as he posited in his essay *Le nouveau monde amoureux*. Fourier was infuriated by everything the emergent bourgeoisie was bringing forth in terms of form, ownership structures, and values: private ownership, the repression of sexual impulses, the "accumulation of hideous huts" – and the ways of life that were being played out inside them. Fourier wanted Versailles, a culture of generosity and ecstasy – but for everyone, without exploitation of a paying class. As a habitation temple for life as a collective, with collective festivities, Lovag's Maison Gaudet is a revisiting of this idea, a palace for everyone in a future where people live off an unconditional basic income (another of Fourier's ideas), where they no longer have to work and can spend their time between the swimming pool, the palm trees, and the love caves.

The way this bubble world is today, it looks like a folly, a facility for the infamous "one per cent" to disport itself, and yet that's precisely what it shouldn't be. It ought to be a post-capitalist building that melds both nature and architecture organically, but also one that dissolves the systems, the hierarchies and the categories which, until now, have organised and structured our lives together in our late bourgeois society.

It is one of the greater ironies of this particular building that, as a hippie utopia, as an anti-bourgeois fantasy, it was sustained by the funds of an entirely bourgeois financial speculator. Unlike many experimental communes of its day, this alternative bubble world was not the brainchild of critics of society; rather, it was commissioned by a capitalist who had fallen in love with an art student. Here capitalism financed the utopia of the society that was expected to emerge after the former's downfall. Along the way, both regimes converged around the idea of festive celebrations,

4 Antti Lovag, floor plan, undated

5 Antti Lovag, *Maison Bulle*, c. 1979

6 Antti Lovag, *Habitologie*, detail of the
 reinforcements, undated

of unfettered excess. And, evidently, that's what Gaudet found appealing about Lovag: "orgytecture" rather than architecture.

When Lovag accepted the commission for the bubble house, he had just come up with a disarmingly simple technology for building round houses. It involved injecting concrete and polyurethane foam into a spherical corset comprised of iron bars and wire mesh; the surfaces were then cured with a polyester coating so the rainwater would simply pearl away. In Lovag's utopia, everyone would be able to build their own concrete cocoon around their ideal living environment, without the assistance of an architect.

Lovag turned down virtually all his other commission for Gaudet's sake. He built without plans. They would experiment by docking bubbles together only to pull them apart again if they were not satisfied with the result. They channelled the natural course of the stream down marbles steps and through a hall where palm trees grew above huge boulders. From there, pathways led to the cave-like bedroom grottos. Animal furs were laid out beneath the Perspex domes. The bubbles looked like foam turned to concrete, like molecular models. Construction work came to a standstill on numerous occasions; winters came, then made way for scorching hot summers. Lovag met a number of women and had children with them, but that was something he did not want to talk about, a private affair, literally. And still the mistral swept across the hillside, and the cranes began to rust. Lovag did not build another house from the 1980s onwards.

In spite of it all and at the initiative of a village mayor, himself an architecture enthusiast, the building site was declared part of France's national cultural heritage. And then Gaudet died; his house was still a building site and it became dilapidated. Later on, a UK real estate company bought the hillside along with the house and had the construction work completed. Lovag remained on site, Gaudet having granted him the life-long right of residence in his small model of a bubble house.

Antti Lovag was not very well the last time we saw him. He sat motionless beneath the Perspex dome of his bubble house. He had had it painted bright green. His bubble was now his prison, a snail shell with which he was now inseparably fused. His dog had died; only the cats

Coque réali

Exemple de for

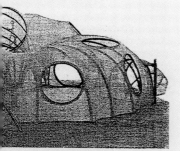

tissu tendu

par tissu tendu.
tte d'Antti Lovag pour une exposition)

carried on breeding, scampering about the bubble house or dozing beneath the blind plastic windows. For a while it looked as if Lovag had nodded off. But then, as we were about to leave, he opened his eyes and said: "Look around. Everything about my architecture is so simple. Did I ever tell you what my dog's called? He's called 'Dog'."

Lovag died on 27 September 2014 at the age of 94. He was still living inside his bubble, to the very end.

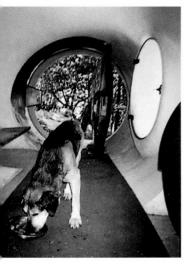

8

7 Antti Lovag, model with upholstery, undated

8 Antti Lovag, prototype, dwelling, Lovag's dog, Tourrettes-Sur-Loup, 2008

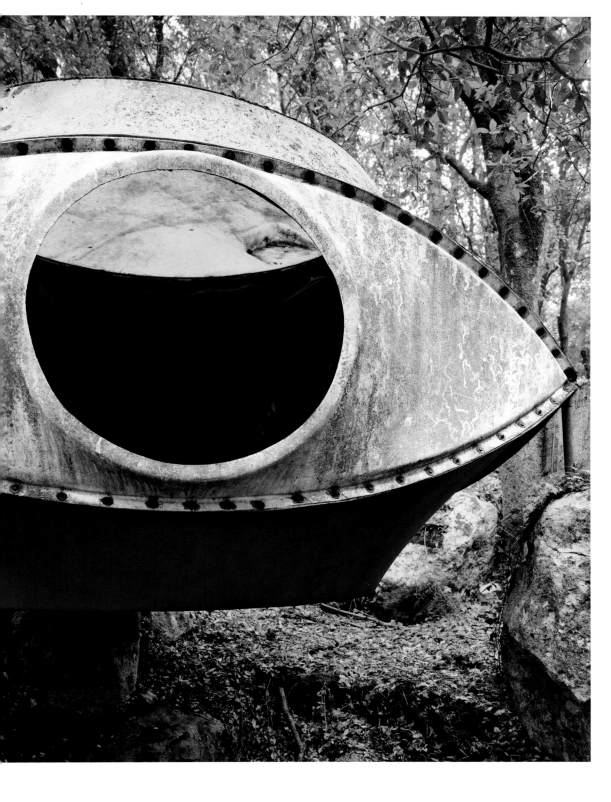

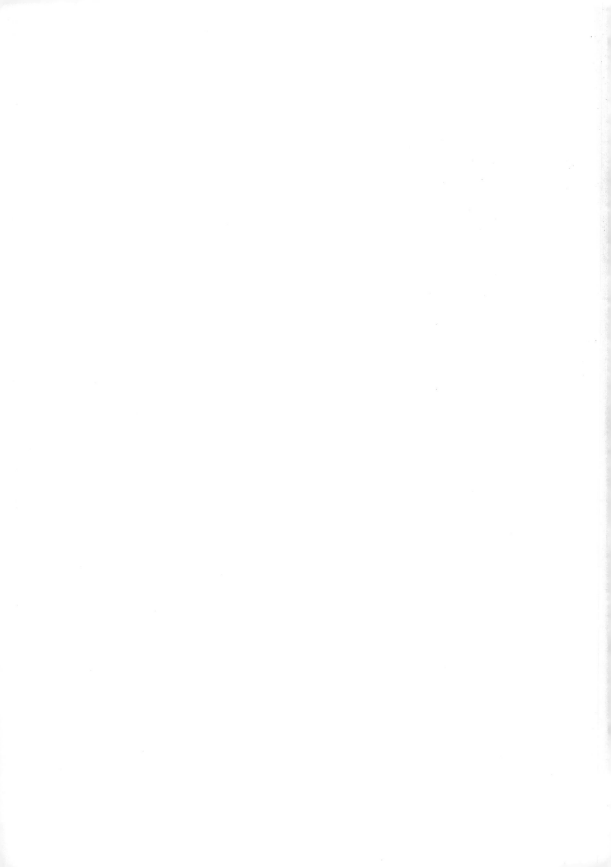

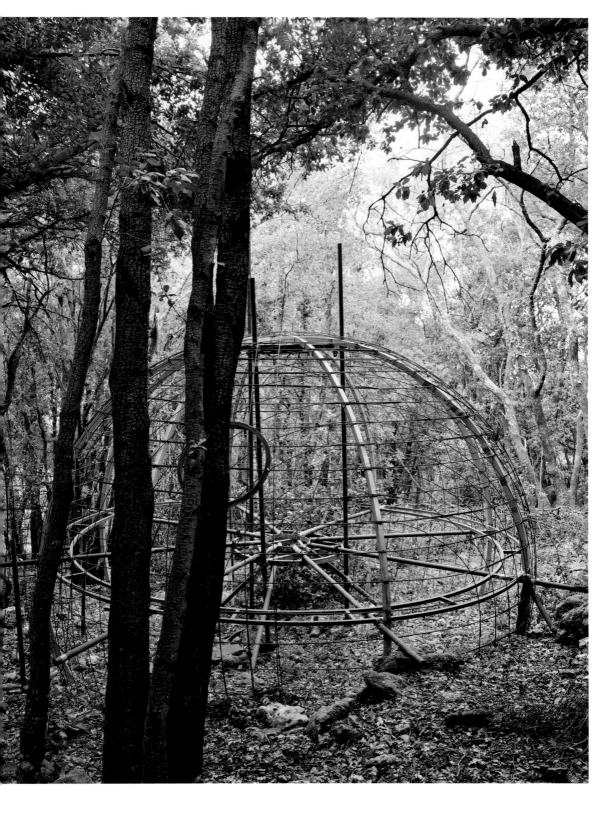

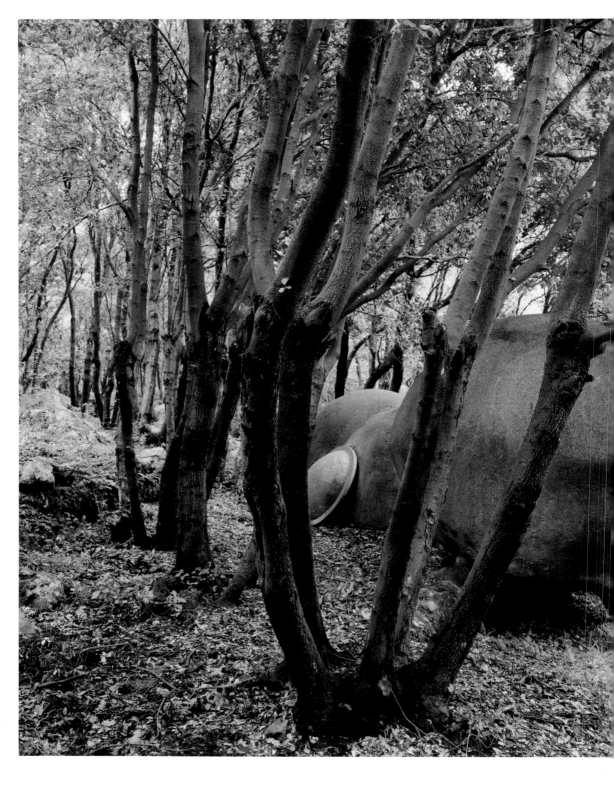

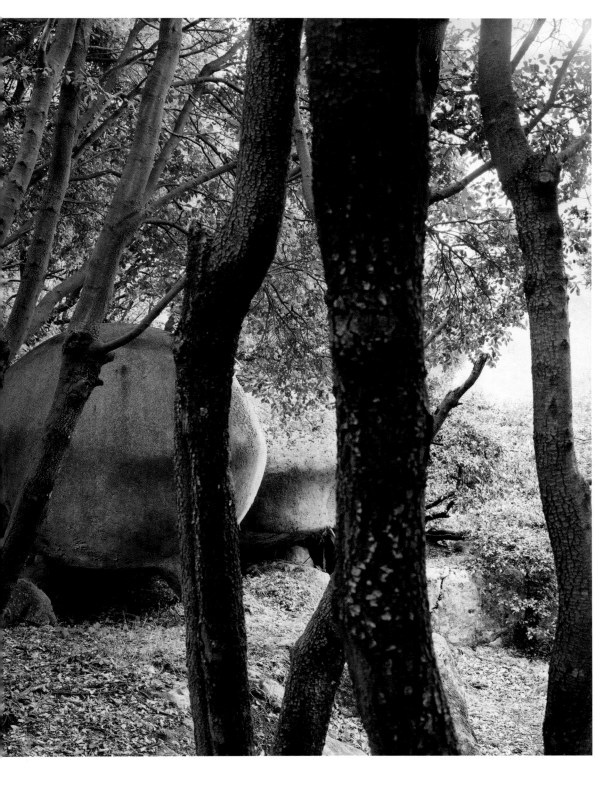

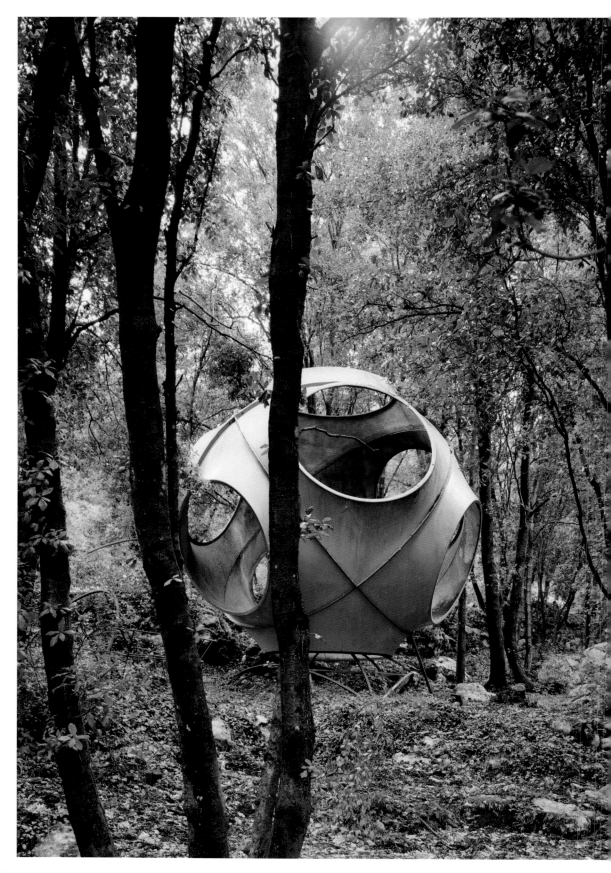

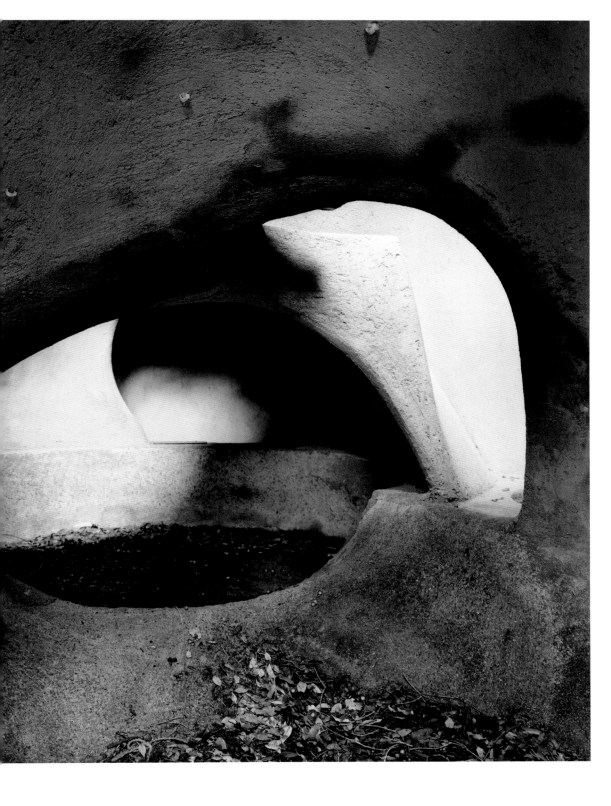

76/77	RENAUDIE/GAILHOUSTET XIII		
	(Centre Jeanne-Hachette) —— 2016 — C-print ——		39 × 49 cm
78/79	RENAUDIE/GAILHOUSTET IV		
	(Centre Jeanne-Hachette) —— 2016 — C-print ——		39 × 49 cm
81	GAILHOUSTET III (Le Liégat) —— 2016 — C-print ——		91 × 72 cm

| 82–113 | DANTE BINI | | |

82	Dante Bini, Cantiere sperimentale — Castelfranco Emilia — 2013		
89	BINI III (La Cupola/Antonioni) —— 2013 — C-print ——		97 × 77 cm
90	BINI II (La Cupola/Antonioni) —— 2013 — C-print ——		97 × 77 cm
92/93	BINI XV (La Cupola/Antonioni) —— 2013 — C-prints (diptych)		97 × 156 cm
95	BINI VIII (La Cupola/Antonioni) —— 2013 — C-print ——		97 × 77 cm
96	BINI IV (La Cupola/Antonioni) —— 2013 — C-print ——		97 × 77 cm
99	BINI V (Cantiere sperimentale) —— 2013 — C-print ——		97 × 77 cm
100/101	BINI I (Cantiere sperimentale) —— 2013 — C-print ——		126 × 159 cm
102	BINI IX (La Cupola/Antonioni) —— 2013 — C-print ——		91 × 72 cm
103	BINI XI (La Cupola/Antonioni) —— 2013 — C-print ——		91 × 72 cm
105	BINI VII (Cantiere sperimentale) —— 2013 — C-print ——		97 × 77 cm
106	BINI XI (Cantiere sperimentale) —— 2013 — C-print ——		97 × 77 cm
108/109	BINI XVI (La Cupola/Antonioni) —— 2013 — C-prints (diptych)		97 × 156 cm
110/111	BINI XIV (Cantiere sperimentale) —— 2013 — C-print ——		77 × 97 cm
113	BINI XII (La Cupola/Antonioni) —— 2013 — C-print ——		97 × 77 cm

| 114–135 | HANS WALTER MÜLLER | | |

114	Hans Walter Müller, Maison Müller, Aérodrome Salis — La Ferté-Alais — 2012		
120/121	MUELLER IV (Maison gonflable) —— 2012 — C-print ——		46 × 59 cm
123	MUELLER I (Maison gonflable) —— 2012 — C-print ——		59 × 46 cm
124	MUELLER VII (Maison gonflable) —— 2012 — C-print ——		46 × 59 cm
125	MUELLER II (Maison gonflable) —— 2012 — C-print ——		59 × 46 cm
126/127	MUELLER VIII (Maison gonflable) —— 2012 — C-prints (diptych)		59 × 94 cm
128/129	MUELLER III (Maison gonflable) —— 2012 — C-print ——		46 × 59 cm
130	MUELLER VI (Maison gonflable) —— 2012 — C-print ——		59 × 46 cm
132	HANS WALTER MÜLLER II (Ferté-Alais) 2012 — C-print ——		39 × 49 cm
133	HANS WALTER MÜLLER III (Ferté-Alais) 2012 — C-print ——		39 × 49 cm
134/135	MUELLER V (Maison gonflable) —— 2012 — C-print ——		46 × 59 cm

| 136–157 | CLAUDE PARENT | | |

136	Claude Parent, Maison Parent (Maison des peupliers) — Neuilly-sur-Seine — 2012		
143	PARENT VII (Oblique) —— 2016 — C-print ——		131 × 103 cm
144/145	PARENT VIII (Église oblique) —— 2016 — C-print ——		39 × 49 cm
146/147	PARENT III (Oblique) —— 2016 — C-print ——		103 × 131 cm
148/149	PARENT II (Oblique) —— 2016 — C-print ——		103 × 131 cm
150/151	PARENT I (Oblique) —— 2016 — C-print ——		103 × 131 cm

152/153	*PARENT IV* (Oblique)	2016 — C-print	103 × 131 cm
154/155	*PARENT V* (Oblique)	2016 — C-print	103 × 131 cm
156/157	*PARENT IX* (Église oblique)	2016 — C-print	39 × 49 cm

158—187 ANTTI LOVAG

158	Antti Lovag, Maison bulle maquette — Tourrettes-sur-Loup — 2012		
167	*LOVAG I* (Prototype/Forêt)	2013 — C-print	182 × 144 cm
168/169	*LOVAG V* (Prototype/Forêt)	2013 — C-print	49 × 61 cm
170/171	*LOVAG III* (Prototype/Forêt)	2013 — C-prints (diptych)	93 × 148 cm
173	*LOVAG VI* (Prototype/Forêt)	2013 — C-print	61 × 49 cm
174	*LOVAG VII* (Prototype/Forêt)	2013 — C-print	61 × 49 cm
176	*LOVAG VIII* (Prototype/Forêt)	2013 — C-print	61 × 49 cm
177	*LOVAG X* (Prototype/Forêt)	2013 — C-print	61 × 49 cm
178	*LOVAG IX* (Prototype/Forêt)	2013 — C-print	61 × 49 cm
181	*LOVAG XI* (Prototype/Forêt)	2013 — C-print	61 × 49 cm
182/183	*LOVAG IV* (Prototype/Forêt)	2013 — C-prints (diptych)	109 × 176 cm
184	*LOVAG XII* (Prototype/Forêt)	2013 — C-print	109 × 87 cm
187	*LOVAG II* (Prototype/Forêt)	2013 — C-print	182 × 144 cm

Johanna Diehl, born in 1977 in Hamburg, Germany, lives and works in Berlin. She studied photography and visual arts at the Academy of Visual Arts in Leipzig under Prof. Timm Rautert, Boris Mikhailov, and, as Meisterschülerin, under Prof. Tina Bara. She also studied at the École nationale supérieure des beaux-arts de Paris under Christian Boltanski and Jean-Marc Bustamante. Her works have been shown at various national and international exhibitions, and they are part of collections such as the Sammlung zeitgenössischer Kunst der Bundesrepublik Deutschland, the Ann and Jürgen Wilde Foundation, the DZ Bank Kunstsammlung, and the Bayerische Staatsgemäldesammlungen, Sammlung Moderne Kunst at the Pinakothek der Moderne, Munich. She has received numerous awards, most recently the working stipend of the Foundation Kunstfonds Bonn, the Akademie Schloss Solitude, Stuttgart, the EHF programme of Konrad Adenauer Stiftung as well as a grant from the Deutsche Akademie Rom Villa Massimo for Casa Baldi. www.johannadiehl.com

Niklas Maak, born in 1972 in Hamburg, Germany, lives and works in Berlin. He studied art history, philosophy, and architecture in Hamburg and Paris and he completed his PhD on the work of Le Corbusier and Paul Valéry in 1998. He was a visiting professor for the history and theory of architecture at Städel Schule, Frankfurt, and teaches at Harvard and in Berlin. After several years at the *Süddeutsche Zeitung*, he joined the *Frankfurter Allgemeine Zeitung* in 2001 as editor for the features section where, together with Julia Voss, he is now head of the arts department. His publications include *Le Corbusier: the Architect on the Beach* (2010), *Fahrtenbuch. Roman eines Autos* (2011), and *The Living Complex. From Zombie City to the New Communal* (2015). For his essays, Maak has been awarded the George F. Kennan Prize (2009), the Henri Nannen Prize in Germany (2012), the COR Prize for architectural criticism (2014), and the BDA Prize for architectural criticism (2015).

YONA FRIEDMAN Yona Friedman, *Machbare Utopien. Absage an geläufige Zukunftsmodelle*, with a foreword by Robert Jungk, from the French by Joachim A. Frank, Frankfurt am Main: S. Fischer, 1977. ———————— Yona Friedman/Manuel Orazi, *Yona Friedman. The Dilution of Architecture*, ed. by Nader Seraj (exh. cat. Archizoom, École Polytechnique Fédérale de Lausanne – EPFL), Zurich: Park Books, 2015. ———————— Cornelia Escher, *Zukunft entwerfen. Architektonische Konzepte des GEAM (Groupe d'Études d'Architecture Mobile) 1958–1963*, Zurich: Architektonisches Wissen, 2017.

CINI BOERI Cecilia Avogadro (ed.), *Cini Boeri. Architetto e designer*, Milan: Silvana Editoriale, 2004. ———————— Cini Boeri, *Le dimensioni umane dell'abitazione. Appunti per una progettazione attenta alle esigenze fisiche e psichiche dell'uomo*, Milan: Angeli, 1981.

RENÉE GAILHOUSTET Renée Gailhoustet, *Eloge du logement*, Paris: Massimo Riposati Editeur, 1993. ———————— Renée Gailhoustet, *Des racines pour la ville*, Paris: Les Éditions de l'Épure, 1998.

DANTE BINI Antonio Pennacchio/Giulia Ricci (eds.), *Dante Bini — Mechatronics*, Milan: postmedia books 2016. ———————— Dane Bini, *A Cavallo d'un soffio d'aria. L'architettura autoformante*, with a foreword by *Gianfranco Dioguardi*, Milan: Guerini e Associati, 2009. ———————— William McLean, *Building with Air*, self-published, 2014.

HANS WALTER MÜLLER Alain Charre, *Hans-Walter Müller et l'architecture de la disparition*, Paris: Archibooks, 2012. ———————— Juan Herreros, *Housing and Domestic Space in XXI Century*, Madrid: La casa encendida, 2008.

CLAUDE PARENT Claude Parent, *Vivre à l'oblique. L'aventure urbaine*, Paris: Dermont, 1970. ———————— Claude Parent, *L'œuvre construite, l'œuvre graphique*, ed. by François de Mazières and others (exh. cat. Cité de l'architecture et du patrimoine, Paris), Orléans: Editions HYX, 2010. ———————— Michel Ragon/Claude Parent, *Monographie critique d'un architecte*, Paris: Dunod, 1982. ———————— Manfredi Nicoletti, *Claude Parent. La funzione obliqua*, Turin: Testo & Immagine, 2003. ———————— Jean Nouvel, "Claude Parent portrayed by Jean Nouvel", in: *Domus*, 28. 5. 2010.

ANTTI LOVAG Pierre Roche, *Antti Lovag. Habitologue*, Nice: France Europe Éditions, 2010 ———————— Raphaëlle Saint-Pierre, *Maisons-bulles. Architectures organiques des années 1960 et 1970*, Paris: Éditions du Patrimoine Centre des monuments nationaux, 2015.

Project supervision
Kerstin Ludolph

Project management
Karen Angne, Katja Durchholz

Translations from German
Stephen Grynwasser, London

Copy-editing
Chris Murray, Nantwich

Graphic design and
typesetting
Studio Jung, Berlin

Prepress and repro
prints professional, Berlin

Paper
Garda Ultramatt, 150 g/m^2

Typefaces
Radikal, Augereau

Production
Katja Durchholz

Printing and binding
Printer Trento S.r.l., Trento

Printed in Italy

Bibliographic information
published by the Deutsche
Nationalbibliothek
The Deutsche National-
bibliothek lists this
publication in the Deutsche
Nationalbibliografie; detailed
bibliographic data is available
on the Internet at
http://www.dnb.de.

ISBN: 978-3-7774-2947-2
(English edition)
ISBN 978-3-7774-2883-3
(German edition)

www.hirmerpublishers.com

Cover illustrations
Front: Johanna Diehl, LOVAG I
(Prototype/Forêt), 2013,
C-print, 182 x 144 cm
Back: Johanna Diehl,
BINI VIII (La Cupola/Antonioni),
2013, C-print, 97 x 77 cm

Photo credits
FRIEDMAN 1–2: © Yona
Friedman/FAZ/Niklas Maak,
3: © Privatarchiv Yona Friedman,
4, 6, 8: © Yona Friedman,
5, 7: © Niklas Maak; BOERI
1, 3, 6–8: © Paolo Rosselli,
2: © Masera, 4: © Stefano Boeri,
5: © Archivi Boeri; 9: © Archivio
Cini Boeri; GAILHOUSTET
1–6: © Archiv Renée Gailhoustet;
BINI 1–6: © Andrej Tarkowskij
Archiv, Florenz, 7: © Enrica
Antonioni; HANS WALTER
MÜLLER 1–2: © Archiv Müller,
3: © HW Müller, 4: © Andy
Shapiro/Kelly Gloge, 5: © Dennis
Conrad, 6: © maschekS,
7: © John Offenbach,
8: © Raumlabor Berlin; PARENT
1: © Archiv Parent/Foto: Naad
Parent, 2: © J.M. Place, 3:
© Claude Parent, 4: © Gilles
Ehrmann, 5. © Eric Martin,
6, 8–9: © Archiv Claude Parent,
7: © Archiv Claude Parent/Foto:
Niklas Maak, 10: © Patrice
Goulet; LOVAG 1–2,7: © Antti
Lovag, 3: © Peter Stumpf, Fonds
de Dotation Maison Bernard,
4,6: © Pierre Roche, 5: © Maxppp,
8: © Niklas Maak

Acknowledgments
Karen Angne, Julia Apitzsch-
Haack, Anna Bini, Dante Bini,
Katja Blomberg, Stefano Boeri,
Cini Boeri, Jean-Baptiste
Decavèle, Hildegard Diehl-Bode,
Katja Durchholz, Yona Friedman,
Renée Gailhoustet, Alan Gray,
Stephen Grynwasser, Jean-
Baptiste Joly, Christopher Jung,
Gregorio García Karman/
Akademie der Künste Berlin,
Leo Kaufmann, Lena Kiessler,
Barbara Liepert, Antti Lovag,
Kerstin Ludolph, Bernhard Maaz,
Mailena Mallach, Hans Walter
Müller, E.R.Nele, Claude Parent,
Naad Parent, Gérard Paris-
Clavel, Jean Renaudie,
Marieanne Roth, Maya Sach-
weh, Raphael Sbrzesny, Jan
Scheffler, Malte Seibt, Thomas
Skiba, Barbara Thiel, Wilma
Tolksdorf, Gertrude Wagen-
feld-Pleister, Gabriele Worgitzki,
Thomas Zuhr